A South Carolina
Album, 1936–1948

*to Les and Maureen
with affection*

Connie Shulz

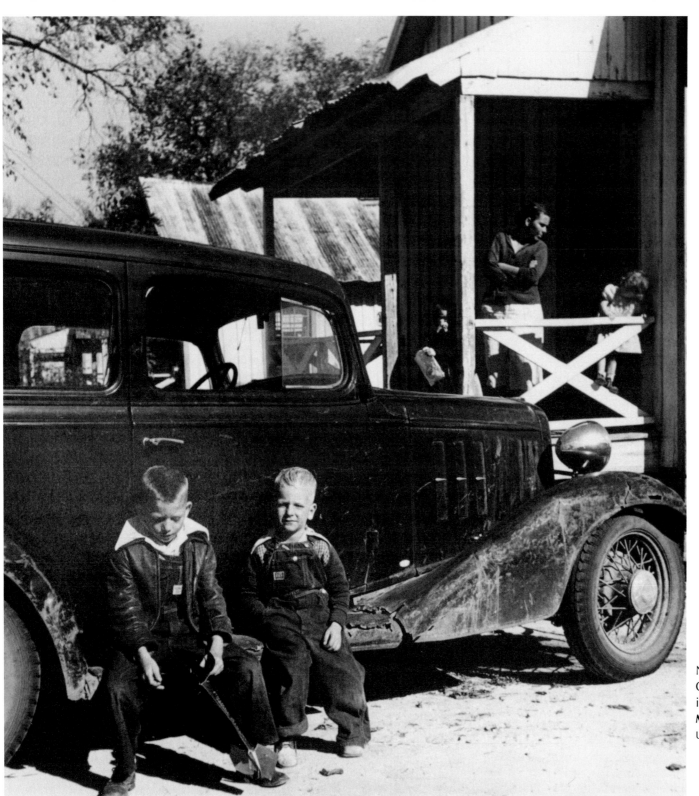

November 1948. Sand Hill Country.
Cotton mill worker's children
in Horse Creek Valley.
MARTHA ROBERTS
University of Louisville Neg. 53154

A South Carolina Album, 1936–1948

Documentary Photography in the Palmetto State

from the Farm Security Administration,
Office of War Information,
and Standard Oil of New Jersey

edited by Constance B. Schulz

University of South Carolina Press

Copyright © 1992 University of South Carolina

Published in Columbia, South Carolina, by the
University of South Carolina Press

Manufactured in the United States of America

Library of Congress Cataloging- in-Publication Data

 A South Carolina album, 1936–1948 : documentary photography in the
Palmetto State from the Farm Security Administration, Office of War
Information, and Standard Oil of New Jersey / edited by Constance B.
Schulz
 p. cm.
 Includes bibliographical resources and index.
 ISBN 0–87249–816–6 (pbk.: acid free)
 1. South Carolina–Description and travel–views. 2. South
Carolina–Social conditions–Pictorial works. 3. Depressions–1929–
South Carolina–Pictorial works. 4. Photography, Documentary–
South Carolina. I. Title
F270.S38 1991
975.7'042–dc20 91–20241

Contents

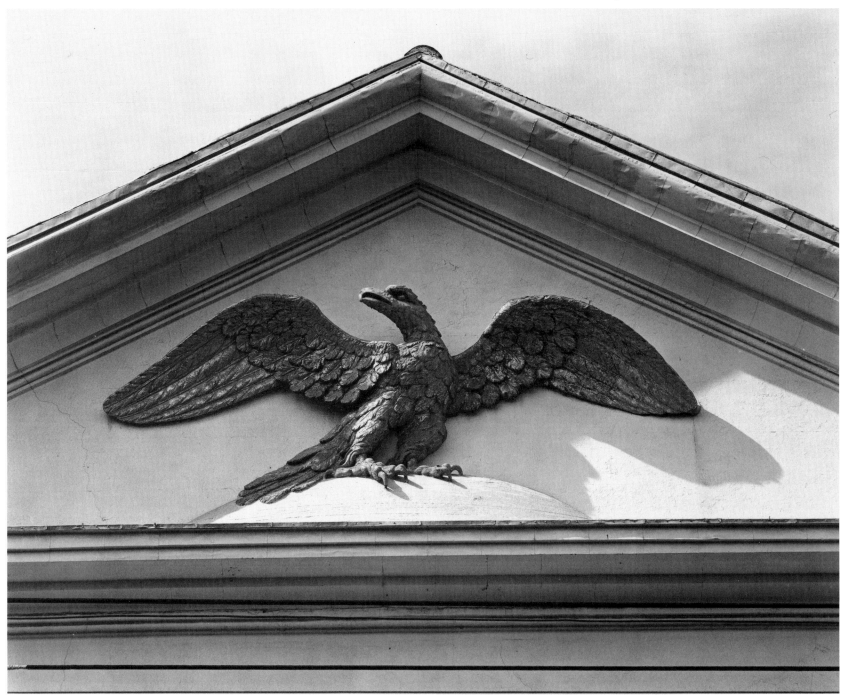

March 1936. Charleston.
A gilded pediment eagle on a building.
WALKER EVANS
LC-USF34 T01 8044

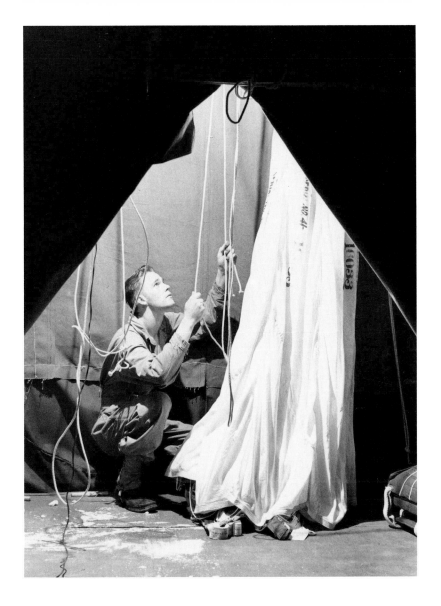

Preface

The genesis of this book is of many years standing. In part its publication honors a long-standing scholarly debt I owe to Ray Smock and Pete Daniels, who fifteen years ago introduced me to the riches of the photographic collections of the Library of Congress, and first took me by the hand and led me to the vertical filing cabinets in the reading room of the Prints and Photographs Division where the photographic prints of the Farm Security Administration and Office of War Information files are kept. More recently, F. Jack Hurley has shared unstintingly his broad knowledge of the FSA/OWI files and the interesting and committed people who created them. It was he who introduced me to the staff and collections of the Ekstrom Library, Photographic Collections, University of Louisville, where James C. Anderson has been helpful in making the Standard Oil of New Jersey photographs available for this publication. As I became aware of a growing number of books featuring FSA/OWI photographs for a single state, and expressed an interest in bringing together such a volume for South Carolina, both Hurley and Anderson encouraged me to expand the "state study" tradition by including Roy Stryker's later work for Standard Oil as part of the record of those decades.

My awareness of the many fine photographs of South Carolina taken by the FSA/OWI photographers was one of the outgrowths of the statewide and national search for images that I conducted for the *History of South Carolina Slide Collection* (Orangeburg, SC, and Annapolis, MD: Sandlapper Press and Instructional Resources Corporation, 1989). By supporting the research for that project, the South Carolina Humanities Council helped to prepare me for this study as well. Allen Stokes, Eleanor Richardson, and Tom Johnson provided much help at the South Caroliniana Library, where a number of prints made from the Library of Congress negatives are available for study. Doug Denatale, the folklore coordinator at McKissick Museum at the University of South Carolina, made available to me the museum's copy of the microfilm reels of the "lots" in the FSA/OWI collection in which images of South Carolina appear. My daughter Jessica spent many hours making paper copies from the microfilm that enabled me to study the photographs for preliminary selection, enthusiastically recommending particular images. My colleagues in the University of South Carolina Department of History, John G. Sproat, Thomas E. Terrill, and Marcia Synnott, shared their special knowledge of South Carolina banking, agricultural, and economic problems during the years of the Depression. Charles Lesser, senior historian

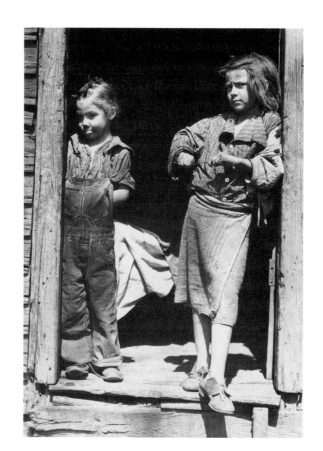

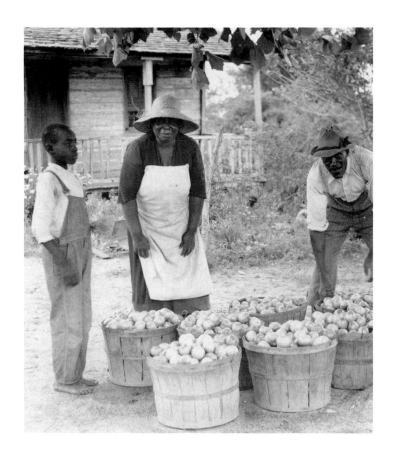

at the South Carolina Department of Archives and History, and F. Jack Hurley submitted the introduction to their careful review. My good neighbor Ada Thomas shared her sharp proofreader's eye and her memories of the years chronicled by the manuscript that she so capably corrected.

While serving as a consultant for a 1990 exhibit and symposium at the South Carolina State Museum entitled *New Deal Art in South Carolina*, organized by Lise Swensson, in which a few of these fine photographs appeared, I had the great pleasure of meeting Jack Delano and hearing him describe to a spellbound audience some of his own reactions to the conditions and the people he had photographed in South Carolina half a century ago. His continued passionate commitment to photography as an art that, through teaching, can make a difference in people's lives has been part of the inspiration for the choices in this volume.

Photographs reproduced in this album from the Farm Security Administration and the Office of War Information are from the files of those agencies in the collections of the Prints and Photographs Division of the Library of Congress. The Standard Oil of New Jersey photographs are in the collections of and reprinted with the permission of the Ekstrom Library, University of Louisville.

A South Carolina
Album, 1936–1948

Introduction

The events of what historians have called Black Thursday— October 24, 1929, the beginning of the stock market crash that set off the Great Depression—made almost no immediate impression in South Carolina. For October 24, 1929, was also "Big Thursday," the annual football contest at the State Fairgrounds between the University of South Carolina and Clemson. The financial news from New York was crowded out by Clemson's 21-14 victory, relegated to the bottom of the front page of *The State*, and pushed back to page seventeen of Friday's *Columbia Record*.

Yet the two decades that followed the events of the financial crisis of 1929 changed South Carolina permanently and irrevocably. The photographs in this volume catch the Palmetto State and its people in the moments of that change. Though taken scarcely more than a half century ago—within the living memory of many who don't yet think of themselves as elderly—they show us a way of life so remote from our own as to evoke a powerful nostalgia. Taken collectively as we turn the photographic pages from 1936 to 1948, they also carry in them unobtrusive hints of the new world we have become. Mules are replaced by tractors in the gently curving plowed furrows of farmland. Pre-fabricated modern houses for displaced rural workers moved off the land by wartime training needs and Santee Cooper's power generation for a new industrial age spring up in barren fields where dilapidated wood frame shanties had housed black and white sharecroppers. Dirt roads rutted by mule-drawn farm wagons become paved highways on which massive trucks roar to distant markets. Shy young men in bare feet and overalls on a cabin porch give way to tough teens

sitting behind a steering wheel, cigarette in hand, or to no-nonsense uniformed soldiers. Land ravaged by erosion is transformed into neat rows of pine forests to be harvested for a growing paper industry. From the ashes of an old way of life—rural, leisurely, isolated, often poor—emerges at last a twentieth-century culture: smoke-stacked industry, automobiles and modern schoolbuses, and children's noses pressed against store windows where manufactured toys promise a "Merry Christmas."

Many of the changes that took place in South Carolina during these two decades were driven by forces that were generated outside of the state. The depression precipitated in the rest of the nation by the stock market crash was already well under way in South Carolina in 1929. Deepening economic hardships in the nation as a whole ensured that during the 1930s, local and state efforts to relieve distress and restructure the economy—and inevitably the society dependent on that economic base—were supplemented and eventually replaced by national efforts. The federal government initiated a host of "New Deal" programs to end depression conditions and provide assistance to individual citizens. Their impact on the state was broad: new banking practices; systems to extend credit to poor farm families; removal of vast acreages of land from cotton and tobacco growing; money for construction of buildings and roads; emergency employment of workers under WPA to build sanitary sewer systems, describe and transcribe state and local records, run kindergartens, repair playgrounds, or build sidewalks and curbs. All contributed to the South Carolina economy and reshaped the South Carolina landscape. The onset of World War II accelerated changes begun during the Depression. Building extensive new army and air training bases, enlarging existing naval and marine facilities, and granting contracts to South Carolina firms manufacturing military supplies, the federal government further enhanced its presence in South Carolina, shifting the economy still farther away from dependence on its agricultural roots.

This introduction first sketches a broad non-political overview of the state between 1920 and 1948 to provide the overall context of change in South Carolina during the decades illustrated by the photographs. It then examines briefly the history of the agencies that created the photographs, the role of Roy Stryker, the man who directed the three photographic projects from which images are brought together here for the first time, and the way that the agencies and the photographic projects functioned in South Carolina. Finally, because the point of view of the photographers who peered through their viewfinders to record specific images is an important consideration in evaluating photography both as documentary record and as aesthetic cultural artifact, the introduction concludes with biographical sketches of Roy Stryker and the photographers who came to South Carolina under his direction.

South Carolina, 1920-1948: An Overview

South Carolinians did not associate the Wall Street stock market crash with economic crisis because by 1929 they had already experienced severe economic hardship for nearly a decade. Still heavily dependent upon agriculture, the state economy suffered a series of debilitating blows that affected many of its citizens directly, and all of them indirectly. Cotton prices had reached record highs of forty cents a pound during World War I, but by early 1921 had plunged to nine cents. During the next five years, cotton prices

stabilized somewhat around twenty cents a pound, but in 1926 they began a steady decline toward the "six cent cotton" despaired of in popular song. At the same time as prices dropped, so too did cotton production in South Carolina. The boll weevil infestation, first introduced into the southwestern United States in the 1890s, crossed the state borders during the war and began to ravage crops. The 1920 cotton crop of 1.6 million bales dropped to half a million in 1922, returned to a million in 1926 and again in 1930, then dropped again. The value of the cotton crop declined from $307 million to $72 million between 1920 and 1929, then receded to $26 million by 1932. Although cotton represented 70 percent of the value of all South Carolina farm crops in 1920, it was not alone in its decline: tobacco plummeted so much in value that by 1932 farmers unable to sell their crop hauled it home from market and plowed it back into the soil as fertilizer. Total value of crop production in South Carolina fell from $446 million in 1918 to $156 million in 1929, and stood at $63 million in 1932.

Because farmers had borrowed to buy land, and had borrowed again to buy seed, chemicals to kill the boll weevil, fertilizer for their relatively poorer soil, and necessities for their families, as farm income declined, so too did the state's banks. Already in serious trouble long before the stock market crash, forty-five banks failed in 1926—more than the failures of any single year of the Depression itself; between 1921 and 1929, 225 banks, or roughly half of the 447 banks active in the state at the end of the war, had failed. Although the bank failures had a number of causes, important among them was the declining value of the agricultural lands that served as loan collateral during the 1920s. Pushed off the land by crop destruction, low prices, and mortage foreclosures, a quarter of a million South Carolinians (three fourths of them

black) had moved out of the state by 1929. Others who lost their land became renters or sharecroppers; farm tenancy increased to nearly 70 percent by 1930, when 103,000 of the state's 158,000 farms were operated by sharecroppers, share tenants, or cash renters. Still others, particularly white sharecroppers in the Piedmont, moved off the land into the growing number of textile mill villages, where wages remained low but were better than the return from farming. It is little wonder that in the face of these hardships, while other parts of the nation grew and prospered, South Carolina's population growth slowed to barely three percent between the 1920 and 1930 census, and black population fell from 865,000 to 795,000; for the first time in over a century blacks constituted fewer than fifty percent of the state's 1.7 million residents.[1]

It is not surprising then that most South Carolinians remember the Depression years of the 1930s not for the arrival of bad times, but instead recall those days as a continuation of long-standing hardship. "We never did have much but each other and the church and the vegetables from Mama's garden," recalled one grandmother interviewed for a class assignment by a recent University of South Carolina history student. When the Depression came her family just "tightened our belts a little bit more and went on like we always did." Tighten their belts they did, for the already low 1929 per capita annual income of $261 in South Carolina by 1932 had

1. Sources for statistics include: John G. Sproat and Larry Schweikart, *Making Change: South Carolina Banking in the Twentieth Century* (Columbia: South Carolina Bankers Association, 1990), pp. 49-51, 69; Mary Katherine Cann, "The Morning After: South Carolina in the Jazz Age" (Unpublished Ph.D. dissertation, University of South Carolina, 1984), pp. 20-21; Lewis P. Jones, *South Carolina: A Synoptic History for Laymen* (Columbia: Sandlapper Press, 1971), p. 235; George Rogers, "South Carolina," in David C. Roller and Robert W. Twyman, eds. *The Encyclopedia of Southern History* (Baton Rouge: Louisiana State University Press, 1979), p. 1141; Jack Irby Hayes, "South Carolina and the New Deal, 1932-1938" (Unpublished Ph.D. dissertation, University of South Carolina, 1972), pp. 406-411.

fallen to $151. Wages for blacks, consigned to unskilled urban work and overwhelmingly represented among farm laborers, reached as low as fifty cents a day for farm work, if indeed work could be found. With little or no income to spend, South Carolinians bought little from stores, and by 1932 retail merchants began to fail. Frightened by earlier bank failures from depositing what little cash they acquired in banks, people hoarded small amounts or put their money for safekeeping in that unique South Carolina institution, the cash depository. On New Year's Day, 1932, the largest bank in South Carolina, Peoples State Bank, headquartered in Charleston but with forty-two branches in thirty-nine towns, closed its doors and did not reopen. By the time Franklin D. Roosevelt declared a bank holiday and closed all national banks in March, 1933, and Governor Ibra C. Blackwood reluctantly followed suit on March 6 and closed all remaining South Carolina state banks, only 119 banks were in operation in the state.[2]

Late in the 1920s, in the face of falling revenues, industry and the state and national governments nevertheless undertook three large-scale building projects that provided a substantial number of jobs in South Carolina, and literally paved the way for the transportation, electrical power, and military installation revolutions that changed the face of South Carolina in the next two decades. In 1929, Governor John G. Richards persuaded the state legislature to float a $65 million bond for the building of state highways. In 1925 there had been 170,000 registered automobiles, but only 228 miles of paved roads. By 1933, not only had several thousand men escaped unemployment by doing road construc-

tion, but 3,200 miles of the 6,000-mile state highway system were paved. Federal funds in the 1930s further expanded roadbuilding efforts, and by 1941, when military needs demanded good roads, 6,600 of the state's 9,680 miles of roads were paved.

The Saluda River Dam project, begun in 1927 with the construction of what was then the largest earthen dam in the world, was completed in 1930. Though many farmers were displaced as Lake Murray inundated thousands of acres in Lexington, Saluda, Newberry, and Richland counties, thousands of workers were given employment, and Lake Murray's waters provided electricity at reduced prices to lure new manufacturing to the state. A second hydro-electric construction project, the Santee Cooper, was authorized legislatively in 1934, but because of legal challenges construction did not begin until 1939. Completed in 1942 with the labor of several thousand men, the project did not contribute to employment opportunity during the leanest of the Depression years, but it did increase the electric generating capacity of the state. Santee Cooper drew $21.7 million in federal grant funds and an additional $26.5 million in loans into South Carolina. The third project that provided work in South Carolina was also federal. In November of 1931, the Veterans Administration began construction of a veterans' hospital in Columbia, for which contractors eventually hired over 650 men, two-thirds of them from South Carolina.[3]

Such efforts were not enough to prevent widespread unemployment. By the end of 1933, nearly one fourth of the state's

2. Oral History Interviews of the Great Depression, Schulz History 202 class, on deposit in South Caroliniana Library; Hayes, "South Carolina and the New Deal," p. 152; Sproat and Schweikart, *Making Change*, pp. 84-92, 202.

3. Jones, *Synoptic History*, pp. 237-243; Ernest McPherson Lander, Jr., *A History of South Carolina, 1865–1960*, 2nd ed. (Columbia: University of South Carolina Press, 1970), pp. 103-105; Walter B. Edgar, *History of Santee Cooper, 1934-1984* (Moncks Corner, SC: South Carolina Public Service Authority, 1984), pp. 5-11; Paul Stroman Lofton, "A Social and Economic History of Columbia, South Carolina, During the Great Depression, 1929-1940" (Unpublished Ph.D. dissertation, University of Texas at Austin, 1977), pp. 49-64.

population was on relief. Federal funds for work relief and for direct relief came to South Carolina first under the Emergency Relief and Construction Act, signed by President Herbert Hoover in July, 1932; within a year, more than $6 million in federal relief funds had been granted to South Carolina. One of the early programs of the New Deal, the Emergency Relief Act of May 1933 (later replaced by the Civil Works Administration) continued and expanded this relief effort. Work relief projects under the CWA included sewing-room and day-nursery jobs for women, and work for men building roads or draining malarial swamps. Together work and direct relief provided support for 89,326 families, affecting 403,255 persons out of the state's total population of 1.7 million. More than half of those who received work relief jobs were black, although in general blacks received the least skilled and lowest paying relief jobs, and then were paid less than whites doing comparable work. For both black and white families, such jobs often meant the difference between survival and starvation.[4]

From 1935 to 1943, the Works Progress Administration put work relief on a more permanent basis. The WPA expended over $121 million in South Carolina projects. It built or improved 10,000 miles of highways, constructed more than 1,000 public buildings, and installed 500 miles of water mains and sanitary sewers. Its non-construction programs sponsored thousands of recreational, educational, and arts programs that reduced illiteracy, improved the health, and enhanced the cultural environment of South Carolinians.[5]

The relief programs of the 1930s buffered people from some of the worst of the effects of the economic crisis, but the more serious problem faced by state and national government was to create a basis for true economic recovery. In South Carolina, these efforts were most important in two areas: in agriculture and in the textile industry. The first priority was that of finding a way to revive agriculture. The New Deal programs under the Agricultural Adjustment Act, passed in 1933, attempted to reduce production and thus improve prices by providing subsidies for seven basic farm crops, most important of which were cotton and tobacco. Cotton prices did increase slightly, reaching thirteen cents in 1936, but fell again during the 1937-1938 recession. Cotton growing did not become profitable until wartime brought demands for military uniforms. Before then, cotton acreage had been successfully reduced by half, in effect accelerating the transition of state agriculture from its historic dependency on a single crop by permanently reducing cotton production. Subsidies to tobacco growers had the opposite effect; stabilization of tobacco prices around twenty cents a pound in the late 1930s preserved the tobacco industry, and in the postwar years tobacco became the state's most important cash crop, surpassing cotton in value in 1955.

As important as the crop subsidies were other AAA programs to provide farm credit or to encourage farmers to conserve and build up the soil through terracing, fertilization, and planting of crops such as soybeans and grasses that would enrich soils and retain eroded lands. Additional federal programs encouraged diversification into peaches, pine timber, livestock, and other products, and taught farmers and their families more efficient farming methods and food preservation techniques. Although protective legislation tried to help tenants when subsidies paid farmers to take land out of production, enforcement was not always rigorous, and 25,000 tenants gave

4. Hayes, "South Carolina and the New Deal," pp. 175-215.
5. Ibid., pp. 232-262.

up their lands during the 1930s, swelling both the unskilled labor market and the relief rolls.[6]

The initial New Deal solution to industrial recovery was the passage of the National Recovery Act, declared unconstitutional by the Supreme Court in the Schecter case in 1935 but important in South Carolina as a spur to improve wages for workers and prices for owners. The most important industry in South Carolina was the cotton textile industry, whose 230 mills in 1933 employed 80 percent of the industrial work force. Since 1923 the industry had shared in the general decline of cotton; for cotton mills, as for farmers, overproduction and sharply reduced markets severely lowered textile prices. The Depression reduced work hours in many plants to fifty-five hours a week and cut wages by as much as fifty percent; the average mill operative's pay for a work week of fifty-five hours in a South Carolina mill in 1932 was slightly over nine dollars. The NRA codes relaxed federal laws against monopolistic practices, enabling the industry to control prices, but protected workers by enforcing minimum wages of thirty cents an hour and an average forty-hour work week, as well as by allowing labor union organization.

Both labor and management made some gains under NRA. South Carolina unions grew from only 1,200 members in 1933 to nearly 50,000 early in 1934. That September a nationwide strike by the United Textile Workers resulted in the largest labor action in South Carolina history. Over 80,000 workers, many of them not in the unions, walked off the job in protest against failure to punish NRA code violations, particularly of industry "stretchout" practices. Defeat of the strike reduced union membership, but the passage of the Wagner Act in 1935 and the National Labor Standards Act in 1938 protected new union recruitment. By 1939, more than 30,000 South Carolina textile workers were union members, and gains for labor of a forty-hour work week and protected wages seemed secure. For the industry, the NRA codes did raise textile prices, and by 1936 orders were up, profits enabled most textile mills to pay dividends, and South Carolina textile stocks were actively sought on the stock market. A recession in 1937-1938 reversed many of these gains, however, and not until wartime demands for textiles did the industry regain its pre-1923 prosperity.[7]

Indeed, for all of the successes of these and other programs in bringing federal money into the state and preventing even worse dislocation than South Carolinians experienced, true recovery came to the Palmetto State in the transforming activities of World War II. The first act in that dramatic reversal for South Carolina came shortly after Hitler invaded Poland in the fall of 1939: the War Department announced plans on October 11 to expand Camp Jackson, outside of Columbia, into a national training facility for the army. A year later the name of the installation had been changed to Fort Jackson, its importance had been increased by its designation as an "induction center" for new recruits and draftees, and more than $17 million in construction work was completed or under way. By early 1941, Fort Jackson's 32,000 officers and men comprised the fourth largest city in South Carolina.

As events in Europe made it clear that Americans would eventually be drawn into the war, a second large infantry training

6. Ernest McPherson Lander, Jr., *South Carolina: An Illustrated History of the Palmetto State* (Northridge, CA: Windsor Publications, 1988), pp. 126-128; Hayes, "South Carolina and the New Deal," pp. 406-454.

7. Hayes, "South Carolina and the New Deal," Chapter 5 "Business and Labor"; Lander, *South Carolina: An Illustrated History*, p. 128.

camp, Camp Croft, was carved out of forest and farm lands near Spartanburg. South Carolina, blessed with mild winters, low population density, and a strong Congressional delegation, had the weather, the room, and the advocates in Washington to become the nation's armed camp. Numerous airfields, the enormous expansion of the Charleston naval facilities, and the transformation of Parris Island into a primary training center for the U.S. Marine Corps pumped millions of federal dollars directly into the state economy and stimulated a commercial and residential building boom to provide services and housing to military men and their families. The adoption of the Selective Service Act and the enthusiastic enlistment of men in the armed forces added to the military impact on South Carolina. More than 170,000 South Carolina men entered military service, and 2,500 South Carolina women served in the three women's service corps. Beginning in 1943, the military presence in South Carolina also included twenty permanent and eight temporary German prisoner of war camps, whose POWs eventually became a source of labor in agriculture and the lumber industry.

Commerce, industry, and agriculture too were transformed by wartime demands. Government contracts with the textile industry for tents and army clothing soon had most mills working three shifts. New industries rushed into production to meet demands for chemicals and airplane and tank parts. Meat packing and paper and pulpwood production overnight became significant industries. Rationing of essential goods and price controls affected domestic consumption, and the need for meat and poultry products helped shift South Carolina agriculture in new directions. Civilians with extra income from working overtime responded to war bond drives. The lives of all South Carolinians were affected, from high school and college students recruited to help harvest the 1942 cotton crop to kindergarteners and senior citizens who participated in war bond drives. Volunteers worked in Columbia, Greenville, and Charleston USO centers entertaining the thousands of servicemen and women, or rolled bandages for the Red Cross, or searched the skies for enemy aircraft and the shores for violators of blackout regulations.

World War II also put in motion important changes in the population, and strengthened other trends already begun during the Depression that continued in the postwar years. Thousands of black men who had been relegated to low-paying jobs as agricultural laborers and black women restricted to domestic service migrated northward to better-paying wartime industrial jobs. The influx of military personnel brought into South Carolina many non-southerners. After the war, Fort Jackson, the Charleston Navy Yard, and Parris Island remained as important military training centers; many of these men and women became permanent residents of the Palmetto State, or returned to retire there.

South Carolina's economy was revitalized in other ways by the war. The shipbuilding, port, and dock facilities developed in Charleston during wartime laid the basis for an increase in the value of imports and exports in the half decade after the war from $27 million to over $151 million. In the countryside traditional ways of life gave way to new technologies. The Rural Electrification Administration brought electrical power to 28,000 farms by 1940; in 1950 that number had increased to 95,000. Now the decline of an agricultural work force accelerated the shift to mechanization in agriculture. Between 1940 and 1950, South Carolina

farms with tractors increased from 4,800 to over 30,000; farms with trucks increased from 8,200 to nearly 30,000.[8]

Thus by the end of the decade of the 1940s, the Palmetto State was dramatically different from the rural, agricultural, cotton textile, familial, and small-town place it had been in 1920. New industry, new crops, new people, new sources of power, new transportation and communication networks, and new ways of cultivating old crops, organizing existing industries, and regulating the economy—all developed under the pressures of economic crisis and wartime mobilization. The people captured in these photographs are the men, women, and children who lived through those changes.

South Carolina and National Documentary Photography, 1936-1948

The brief retelling of the history of South Carolina from 1920 through 1948 does not fully explain the photographs in this album. Just as a family photograph album often does not tell the whole story of that family—because the sporadic decision to take out a camera and make a record, or the point of view of the individual taking the pictures, or indeed the memories and purposes of the person selecting images to put in the album all shape what we remember about our family experiences—this album too represents choice, the presence of particular photographers at a particular time, and a sometimes selective point of view. Alert readers will notice that while this introduction has described

8. Lander, *History of South Carolina, 1865-1960*, pp. 209-223 and Lander, *South Carolina: An Illustrated History*, pp. 131-133; Jones, *Synoptic History*, 251-258; William J. Cooper and Thomas E. Terrill, *The American South: A History* (New York: McGraw-Hill, 1990), 2:689-699.

Depression and wartime conditions in Charleston and Columbia, relatively few photographs of those cities appear below. Rural electrification, large-scale building projects such as the Veterans Administration Hospital and the enlargement of the Charleston Naval Yards, are also missing. Moreover, the postwar retention and expansion of military bases in South Carolina; the growing importance of a tourist industry along the coast; the development of the Savannah River Plant and its nuclear fuel production are not represented either. What then is the basis for bringing together the images in this album?

The pictures in this album are here because during the years 1936 through 1948, three national photographic projects, all under the direction of the same man, Roy Emerson Stryker, amassed an archive of over 150,000 photographic images. These projects were created by two federal agencies, the Farm Security Administration or FSA, and the Office of War Information or OWI, and a major American corporation, Standard Oil of New Jersey or SONJ. Although other programs created photographic records of their activities, no others did so as extensively, and this album comprises images from only these three projects. In the half century since their creation, images from the first two, FSA and OWI, have been used repeatedly to illustrate important truths about depression and war, and have become in many ways the nation's visual memory of those years. In contrast, the SONJ photographs are virtually unknown. One part of the purpose for publishing this album of images from the FSA, the OWI, and the SONJ collections is to illustrate the unity and continuity in South Carolina of the overall direction exercised by Stryker, and of the documentary photographic method employed by the photographers.

Despite the importance of FSA and OWI photographs as a national visual resource, relatively few of the FSA and OWI images of South Carolina have been seen either in the state or elsewhere. During the Depression years, the FSA files were an important source of illustrations for books and magazines telling the story of American hardship and recovery, but almost no South Carolina images were among those chosen. Increasingly since 1965, serious histories, movies, popular magazines, museum exhibits, and other media have turned to the FSA/OWI files to retell the story of the 1930s and the 1940s. Again, few of the images brought to public attention in this renewal of interest in our collective recent national past have been photographs of South Carolina. Some exposure to them has occurred recently within South Carolina itself. The College of Charleston purchased prints from the negatives in the Library of Congress in 1975, and mounted an exhibit of Farm Security Administration images of South Carolina, at which they invited FSA photographer Jack Delano to speak. A 1990 exhibit at the South Carolina State Museum entitled *New Deal Art in South Carolina* featured two dozen FSA photographs. Once again, Jack Delano was a featured guest speaker, and F. Jack Hurley, the biographer of Roy Stryker, gave a scholarly lecture on the activities of the FSA photographers in the Palmetto State. But beyond those limited exposures, South Carolinians have seen little of the rich heritage that is theirs in federal files containing nearly eight hundred images of their state. Over two hundred South Carolina photographs from the Standard Oil of New Jersey collection are virtually unknown. A second purpose of this album then is to focus on the aesthetic and informational values of the images of South Carolina in these important national collections. Such a South Carolina album is needed both for those who live in the state and want to know about its past and those who live outside of the state and have not had an opportunity to see how its experiences fit into the larger picture of a nation in economic distress, during wartime, and beginning postwar recovery.

Because this is an album specifically of FSA, OWI, and SONJ photographs, it is important to look briefly at each project in turn to understand how the photographs fit into the larger mission of the organizations that created them, and how each was active in South Carolina. The FSA photographic file was created by the Historical Section of a federal agency created in 1935 under the title Resettlement Administration, renamed Farm Security Administration and placed under the Department of Agriculture in 1937, and disbanded under wartime pressures and political criticism in 1943. This agency was part of the New Deal attempt to address the serious issues of rural poverty that President Franklin D. Roosevelt and his closest advisers believed had to be faced to bring about recovery and prosperity. Roosevelt appointed Rexford G. Tugwell, a brilliant young professor of economics at Columbia University, to organize and lead it. Tugwell believed he had a mandate to address the increased poverty of the poorest farmers. In addition to resettling these farmers on more productive land, or in suburban communities where they might become part of a labor force for a revitalized American industry, Tugwell also proposed building cooperative rural communities, the creation of model migratory labor camps, and the establishment of small garden home projects for farm laborers.[9]

9. F. Jack Hurley, *Portrait of a Decade: Roy Stryker and the Development of Documentary Photography in the Thirties* (Baton Rouge: Louisiana State University Press, 1972), Chapter 3, passim. On the Resettlement Administration and the Farm Security Administration, see Sidney Baldwin, *Poverty and Politics: The Rise and Decline of the Farm Security Administration* (Chapel Hill: University of North Carolina Press, 1965).

As the agency matured, was restructured through Congressional legislation, and renamed, the FSA operated on a more cautionary agenda for reducing farm tenancy and preserving individual family ownership of farms. Its efforts encompassed three broad goals: tenant purchase programs, rural rehabilitation, and community resettlement. The Tenant Purchase Division enabled tenants, particularly in the rural South, to purchase lands of their own. A number of the successful applicants for this form of FSA assistance in South Carolina appear in the photographs in this album. The Rural Rehabilitation Division included two kinds of loan programs, medical and dental care for poor rural clients, and cooperative group activities. Debt adjustment programs used FSA staff to help indebted farmers renegotiate their loans with creditors to reduce the numbers of farm foreclosures and bankruptcies. Smaller amounts of money for which no repayment was required were given out under a grant program that served immediate emergency relief needs. Although many rural South Carolina families regarded such grants as welfare, for many others, some of whom are pictured below, these small sums of money often meant the difference between survival of the family farming unit, and dissolution of the household and its individual members into homelessness or dependency on relatives and social agencies. The group and cooperative rehabilitation activities were somewhat more controversial. The FSA gave loans "to small groups of client families who pooled their funds for the purchase of breeding stock, farm machinery, and other facilities."[10] A number of South Carolina clients pictured below were encouraged by FSA district and county agents to pool their resources in this way, and received loans for mules, horses, and harvesters and other equipment.

10. Baldwin, *Poverty and Politics*, pp. 201-203.

Community resettlement projects were the third and most controversial part of FSA programs. Twelve such projects were planned and begun in South Carolina, although only three actual communities were ever developed. Ashwood Plantation, an ambitious undertaking of 11,000 acres for 160 white farm families began in 1934 under the Federal Emergency Relief Administration. Orangeburg Farms, originally intended for resettlement of black farmers when begun in 1934, was eventually completed for 67 black and white families with 6,403 acres in segregated areas under separate administrators. Allendale Farms was established in 1938 with 11,334 acres in farms for 117 black and 1 white families when tenants were dislocated by the building of the Santee Cooper Dam and electric power system. Photographs below by Marion Post Wolcott of a community celebration at Ashwood in May of 1939 and by Jack Delano of the Allendale Farms relocation process illustrate well the impact of such projects on South Carolinians.[11]

The photographic file of the Historical Section of the FSA is in some ways the agency's most enduring legacy. From the beginning, Tugwell understood that public relations would be important for his agency, and Stryker and his photographers played a crucial role in educating both Congress and the public about the problems of rural poverty that the FSA had been created to solve and the programs that attempted to solve them. At one level then, the first group of photographs (see images on pp. 24-97) in this album needs to be viewed as part of the record of the activities of a particular federal agency.

11. William David Hiott, "New Deal Resettlement in South Carolina" (M.A. thesis, University of South Carolina, 1986). Hiott devotes chapters two and three of his study to detailed descriptions of the history of the three communal settlements and includes a brief analysis of the present-day use of the areas once part of the settlements.

But Roy Stryker was an agricultural economist with a broader vision than mere public relations. He believed that anything worth studying needed to be approached from all its angles and understood in all its complexity. For eight years under Stryker's administration, the Historical Section built a file of photographic evidence of the nation's agricultural conditions that went far beyond images of FSA actions and successes. Stryker developed a routine of dispatching photographers with detailed instructions of the kinds of images to look for, and an efficient darkroom system whereby staff developed the film, printed the proofs from which the photographers and Stryker selected images for the file, and sent the images back to the photographers for captioning. The growing file of captioned prints in the Washington offices of FSA became the central focus of the Historical Section's mission. Forty-four photographers are credited for the photographs in the FSA files, but the bulk of the work was done by fifteen men and women. Of those, only five were given assignments in South Carolina: Walker Evans, Carl Mydens, Dorothea Lange, Marion Post Wolcott, and Jack Delano. Evans, Mydens, and Lange came to South Carolina briefly during the earliest years of the FSA photographic project. Wolcott made two extended trips in December of 1938, and in the late spring and early summer of 1939. Jack Delano traveled to South Carolina in the spring of 1941.[12]

Beginning in 1939, the momentous events that plunged Europe into war, and eventually culminated in the attack on Pearl Harbor, refocused many New Deal agencies. The FSA was no exception. Increasingly, photographs of preparation for war over-shadowed the images of FSA clients and the conditions under which they struggled for economic improvement. In preparing Americans for the war effort, a not-so-subtle difference in perspective emerged; according to photographic historians Carl Fleischhauer and Beverly Brannan, "affirming photographs had to be added to the file to balance scenes of hard times. In 1939, Stryker wrote to one of his photographers that 'we particularly need more things on the cheery side.'"[13] In South Carolina the new perspective was not necessarily more cheery. To be sure, in May, 1939, Marion Post Wolcott photographed the successful community life and educational programs at Ashwood Plantation, one of the state's three resettlement projects. Its picnic, baseball, and classroom scenes were certainly "affirming photographs." But a second FSA project in South Carolina in these later years showed some of the tensions associated with the continued dislocation caused by both poverty and war. Stryker sent Jack Delano to South Carolina in the spring of 1941 to photograph the process of resettling the tenants and small farmholders who were displaced by the Santee Cooper Dam project and Lake Marion, and the upstate farm poor who were moved off their lands to make room for building Camp Croft. (This later phase of FSA photography is represented below — see images on pp. 71-97)

By 1942, it became clear that the FSA was in political and budgetary trouble, and Roy Stryker began to look for a way to preserve the ongoing documentary photographic work of his Historical Section and its burgeoning file of images. He found a home for both within the Office of War Information, created in July, 1941, to coordinate a proliferation of government propa-

12. Carl Fleischhauer and Beverly Brannan, *Documenting America, 1935-1943* (Berkeley: University of California Press, 1988), Appendix, p. 337; and Library of Congress FSA/OWI collection, microfilm, lots 1525 through 1535.

13. Fleischhauer and Brannan,"Introduction," *Documenting America*, p. 5.

ganda and information efforts. In the fall of 1942, OWI Associate Director Milton Eisenhower placed the photographers, photographic files, and headquarters staff for Stryker's unit within the Bureau of Publications and Graphics, a subdivision of the Domestic Operations Branch. The general approach toward recording American people and their activities through informed documentary photography continued that winter under Stryker's direction within OWI. The task now, however, was to record the successes of home-front activities.[14] In carrying out that task, Stryker sent Jack Delano on an extended trip into South Carolina in the summer of 1943 to record the training activities of an Air Service Command unit in Greenville, a soldier's furlough to his home town of Bowman, and the Army Air Corps activities in Myrtle Beach. Other FSA photographers recorded parachute exercises at Parris Island. The OWI photographs in this album (see images on pp. 98-112) thus reflect the important wartime effort of building support for the war and documenting civilian activities during the conflict.

For Stryker the administrative discretionary power he had enjoyed within FSA was severely diminished under OWI. Caught up in an internal OWI struggle between proponents of wartime propaganda who argued that in a free society full information about all factors affecting the war was essential, and State Department and War Department supporters who insisted that all news should be controlled in support of the war effort, Stryker faced loss of support in Congress for the Domestic Operations Branch, and the loss of many of his photographers to the draft. By early 1943 he realized that his mission within the government had run its course, and began to explore strategies for preserving the photographic file he had created. For eight years, government photographers

had documented a broader range of rural, urban, and small-town activities more comprehensively than any planner had imagined at the start of the project. The more than 107,000 photographic prints gathered by the agencies Stryker directed constituted a unique visual resource of American life.[15] In 1943, Stryker transferred his immense collection of photographs to the Library of Congress. Organized by the historian and archivist Paul Vanderbilt into a regional and subject classification scheme, 88,000 of the photographs from the file remain there today as one of the most widely used photographic resources on American life in the 1930s.[16] His work protected, Stryker resigned from the OWI on September 14, 1943. He went to work almost immediately for Standard Oil of New Jersey. Before he and the thirty different photographers who worked for him at Standard Oil ended their work in 1950, he had amassed another 68,000 images.[17] The last section of photographs in this album (see images on pp. 114-136) are selected from some 200 images of South Carolina created by that project.

15. The number of images created by FSA and OWI varies with the source consulted. Stryker referred to a file of 270,000 pictures created by the Historical Section in his introduction to Roy Emerson Stryker and Nancy Wood, *In This Proud Land: America 1935-1943 as Seen in the FSA Photographs* (Greenwich, CT: New York Graphic Society, 1973), p. 7. This study uses the detailed analysis by Fleischhauer and Brannan, in the Appendix to *Documenting America*, of files transferred to the Library of Congress in 1946. Fleischhauer and Brannan attribute 107,000 prints to what is now called the FSA-OWI Collection, of which approximately 77,000 were produced by Stryker's Section, and the remainder collected from other sources.

16. The story of the dismantling of the Historical Section after its transfer to OWI is told both in Hurley, *Portrait of a Decade*, pp. 166-173, and in Fleischhauer and Brannan, *Documenting America*, pp.7 and 330-342. FSA/OWI images are also available in a microfilm version of the file. Roughly chronological, and grouped more or less by the work of photographers during individual shooting assignments, the microfilm version of the file is divided into "lots" of 30 to 200 photographs, created by Vanderbilt as "a set of prints which it is desired to keep together in some order not provided for by the [subject] classification[s], usually because it is a 'story' conceived and photographed as an interpretive unit." (Cited by Fleischhauer and Brannan, *Documenting America*, p. 332.)

17. Steven W. Plattner, *Roy Stryker: U.S.A., 1943-1950. The Standard Oil (New Jersey) Photography Project* (Austin: University of Texas Press, 1983), p. 16.

14. Ibid., p. 6.

The reasons for the creation of this last collection require a slightly more detailed explanation, because of all of the photographs they are most susceptible to the charge of being "propaganda" or "public relations" rather than documentary in character. In 1943, Standard Oil of New Jersey, the largest of the seven fragments of the industry created by breakup of the John D. Rockefeller monopoly in the 1890s, was in serious trouble with the public at large. Before the war it had enjoyed a worldwide reputation as the leading American producer and distributor of oil-related products. Then a series of Congressional hearings early in 1942 revealed that in 1929 Standard Oil had entered into an agreement with the leading German petrochemical firm, I. G. Farbenindustrie. In exchange for agreeing not to pursue experiments to develop a synthetic substitute for rubber, Standard Oil extracted from Farben a promise not to compete in the petroleum market on American soil. Although testimony by Secretary of Commerce Jesse Jones admitted that the failure of Americans to develop a synthetic rubber industry of their own was as much due to the federal government's reluctance to fund such expensive research as to any accord between Standard Oil of New Jersey and a German industry, press publication of the 1942 hearings created a great stir. Harry Truman, chair of the Senate Committee on National Defense, exclaimed at hearing of the Farben-Standard Oil agreement, "I think this approaches treason." In the heightened emotional tensions of wartime, with American armies hampered in their mobility because Japanese captivity of East Indies and Malaysian sources for natural rubber made tires and other essential rubber products scarce, Standard Oil seemed to be a traitor to the war effort.[18]

To counteract its image as an industry that put profits above patriotism, Standard Oil hired Earl Newsom, director of Madison Avenue's most capable public relations firm, to refurbish the company's tarnished image. Edward Stanley, Newsom's photographic director, suggested that Standard Oil create a documentary photographic record of the impact on America of the oil industry, and recommended that Roy Stryker be hired to direct it. Stanley had worked briefly in the Domestic Services Branch of the OWI, knew how dissatisfied Stryker had become doing wartime propaganda photography, and used their long friendship to persuade Stryker to consider the offer seriously.

For his part, Stryker accepted the position because it seemed to him that he could continue there the work of documenting American life in a way that he had been prevented from finishing in the last years at OWI. The rural visual encyclopedia was virtually complete from the FSA years, but the Standard Oil project gave him an opportunity to shift his focus. Before Stryker was finished, wrote Ulrich Keller, "he wound up generating a composite image of industrial America in general, thus essentially providing a sequel and exact complement to his earlier epic of the rural U.S."[19] Although he had expressed some reservations about taking a job with Standard Oil, and promoting the "good corporate citizen" image of a corporation that many Americans distrusted deeply, Stryker and Standard Oil worked together harmoniously for seven years. For Roy Stryker, "oil is people," just as the Depression and the preparation for war were fundamentally stories of people. According to Keller, the Standard Oil photographers, like the New Deal FSA and the wartime OWI photographers, were "intrigued by

18. Plattner, *Roy Stryker*, pp. 11-12.

19. Ulrich Keller, *The Highway as Habitat: A Roy Stryker Documentation, 1943-1955* (Santa Barbara, CA: University Art Museum, 1986), p. 26.

American society in its entirety, its positive qualities as well as its glaring failures. In their view, America's makers and consumers of petroleum were no less worthy of documentation than the sharecroppers and rural migrants whose lives the FSA photographers had portrayed so eloquently only one decade earlier."[20] The Standard Oil photographic project was eventually discontinued despite its success in this larger goal because it made very little progress in the company's shorter-term aim of better public relations. Stryker resigned in July of 1950 to head the Pittsburgh Photographic Library documentary, and the company continued to use the file he had created until 1960. Believing that the photographs were no longer relevant to company public relations goals, the officers of Standard Oil of New Jersey agreed to the transfer of the project archives to its present home at the University of Louisville.

Standard Oil had no refineries or oil wells in South Carolina, so the efforts of Stryker's photographers in the Palmetto State focused on the way in which oil products—gasoline, petroleum, and industrial lubricants—affected life in a rural state. Arnold Eagle spent a brief period in November of 1947 documenting the pine-growing and paper-manufacturing activities associated with the International Paper Company in Georgetown. Martha Roberts traveled more extensively in the state in November of 1948, photographing the life of cotton growers in the Aiken-Edgefield areas, abandoned buildings in the city of Columbia, and street scenes along the coast in the Beaufort region. Trucks, tractors, schoolbuses, and automobiles spoke eloquently of the ubiquitous presence of oil and its byproducts in South Carolina.

20. Ibid., p. 23.

The photographs from these three projects, taken together, document an era of enormous change in American life. In many ways, the visual record they preserve transcends the narrower purposes for which each of the institutions that created them existed. Without consciously intending to do so, the photographers from these projects who came to South Carolina created a composite picture of the state's transformation from rural poverty to mid-century prosperity.

The Photographers

ROY EMERSON STRYKER (1893-1975)

Born in Great Bend, Kansas, in 1893, Stryker moved with his family to Colorado three years later. A stint in France during World War I, experience working on a ranch, exposure while in college in Golden, Colorado, to the "social gospel" vision of Walter Rauschenbusch, all were part of the mental baggage Stryker brought with him to New York in 1921. Working at the Union Settlement House to make ends meet, Roy and his new wife Alice both became students: he at Columbia University, she at Union Seminary.

At Columbia, Stryker's economics instructor was Rexford G. Tugwell. As Tugwell's student assistant, Stryker began his lifelong interest in photography as a tool for teaching about society while searching for illustrations for his mentor's proposed study *American Economic Life*, a search that, between teaching responsibilities, occupied him from 1924 to 1930. In 1935, Tugwell invited Stryker to come to Washington, D.C., to head the Historical Section of the newly created Resettlement Administration (later Farm Security Administration). Stryker's work with the federal government ended in 1943, when he went to work for Standard Oil of New

Jersey as head of a photographic project to document the impact of oil and its products on American life. He retired from this position in 1950 to head the Pittsburgh Photographic Library. In Pittsburgh he directed a small-scale documentary photography project on the production of steel by the Jones and Laughlin Steel Corporation and continued to consult on photographic projects until the late 1960s, when he moved back west to his boyhood Colorado mountains. In 1973 he collaborated with Nancy Wood on a book of his favorite photographs from the FSA project, *In This Proud Land: America 1935-1943 as Seen in the FSA Photographs* (Greenwich, CT: New York Graphic Society, 1973).[21]

WALKER EVANS (1903-1975)

Born in St. Louis, Missouri, and raised by his prosperous family in the exclusive North Shore suburbs of Chicago, Evans went to school at Phillips Academy, Andover, and attended Williams College before spending time in Paris, where he briefly attended the Sorbonne, and worked in the studio of the French portrait photographer Paul Nadar. The first individual exhibition of his photographs in 1931 at the John Becker Gallery (with Margaret Bourke-White and Ralph Steiner), and an important exhibition at the Museum of Modern Art in 1933 of his photographs of nineteenth-century houses began his rise to recognition, and by 1971 he was "generally acknowledged [as] America's finest documentary photographer of this century." During the early years of the Depression he lived in upper Greenwich Village with the painter Ben Shahn. After doing some photography for the Department of the Interior,

Evans was introduced to Roy Stryker in the fall of 1935. He went to work for the Farm Security Administration on October 9, 1935, as its highest paid photographer. As an established photographic artist, he helped to shape the aesthetic vision of Stryker and the Historical Section. Although he produced fewer photographs in the field than any of the other major photographers associated with the Section, the uncompromising directness and simplicity of his approach make his prints among the most striking of the entire collection. Averse to taking direction from Stryker and unwilling to keep track of his expenses or account for his movements, Evans finally was let go in September, 1937, during a budget crisis in the agency. A 1938 exhibition at the Museum of Modern Art that included some of his FSA photographs, *Walker Evans: American Photographs*, was the first one-man show there by a photographer and brought the FSA photographs for the first time to a critical audience. Evans collaborated with James Agee in 1941 to produce the highly acclaimed *Let Us Now Praise Famous Men*. He worked for *Fortune* magazine as associate editor and photographer from 1945 until his retirement in 1965. He came to South Carolina in March of 1936, but produced relatively few photographs in the state, mostly in Beaufort and Charleston, primarily concentrating his lens on architectural rather than human subjects.[22]

CARL M. MYDANS (1907-)

A native of Boston, Carl Mydans studied journalism at Boston University, and worked as a reporter for *American Banker* before turning his skills to photography. His early work with a 35mm

21. The most complete account of Stryker's life and work through 1943 is Hurley, *Portrait of a Decade*, published before Stryker's death in 1975. Information on his life during the years after FSA can be found in Plattner, *Roy Stryker*, pp. 11-25.

22. George Walsh, Colin Naylor, and Michael Held, *Contemporary Photographers* (New York: St. Martin's Press, 1982), pp.228-230; Hurley, *Portrait of a Decade*, pp. 44-48 and 106; Alan Trachtenberg, *Reading American Photographs: Images as History, Mathew Brady to Walker Evans* (New York: Hill and Wang, 1989), pp. 235-250.

camera, then a relatively new technology, brought him to the attention of the Suburban Resettlement Administration, which hired him as a photographer in 1935. He became part of the Historical Section later that year when his agency was transferred to Tugwell's Resettlement Administration and all photographic projects were consolidated under Stryker. Mydans worked for Stryker for only a year before accepting a position in June of 1936 as photographer and correspondent for the new *Life* magazine. He was employed there until 1972 and did extensive work as a war correspondent in Europe and the Pacific (he was a prisoner of war in the Philippines and China from 1942 to 1943) and later in Korea and Vietnam. Mydans came to South Carolina in June of 1936 as part of a larger trip through the South to document the cotton industry; he traveled widely in the state, and his photographs here include images from Anderson, Cheraw, and Lady's Island.[23]

DOROTHEA LANGE (1895-1965)

Born in New Jersey and educated in public schools in New York, Dorothea Lange studied photography at Columbia University, and worked as an assistant in Arnold Genthe's New York studio. In 1918 she and a friend began a trip around the world, but ran out of money in San Francisco, California, where she established and ran a photographic studio for the next fourteen years. When the Depression began to bring desperate and homeless rural people into the streets of San Francisco, she recorded them with her well-developed portraitist eye and lens. Her work documenting the dust bowl poverty in California brought her to the attention of University of California economist Paul Taylor, with whom she collaborated (and whom she later married) on a

report for the California State Relief Administration. It was her graphic photographic depiction of Depression hardships in this report that brought her to Stryker's attention, and she joined the Farm Security Administration staff late in 1935, although she did not come to Washington until the spring of 1936. Budget cuts in October, 1936, forced Stryker to take her off the payroll and put her on a per diem basis; reinstated in the spring of 1937, Lange was again released because of agency financial difficulties in the fall of 1937, but was rehired in 1938. Her association with the FSA ended in 1939. She was a photographer for the San Francisco branch of the Office of War Information from 1943 to 1945, after Stryker had left that agency, and from 1954 to 1955 she was a photographer for *Life* magazine. She was passionately concerned about the plight of migrant workers, doing her most important FSA photography in California and the west; her photo entitled "Migrant Mother" is perhaps the best known and most enduring image from the Depression years. She came to South Carolina in July of 1937, after being reinstated by Strkyer the first time. Her vivid photographs in Gaffney and Chesnee of sharecroppers and their families illustrate her strong emotional identification with the people she photographed, and her respect for the essential dignity of the poorest victims of the economic crisis.[24]

MARION POST WOLCOTT (1910-1990)

Marion Post grew up in New Jersey until the divorce of her parents led her mother to take a job in New York City working with Margaret Sanger, a leader in the crusade to legalize birth control. Post's

23. Walsh and others, *Contemporary Photographers*, pp. 546-548; Hurley, *Portrait of a Decade*, pp. 4244.

24. Walsh and others, *Contemporary Photographers*, pp. 431-434; Hurley, *Portrait of a Decade*, 68-76; Penelope Dixon, *Photographers of the Farm Security Administration: An Annotated Bibliography 1930-1980* (New York: Garland Publishing, 1983), pp. 53-54.

schooling in Greenwich, Connecticut, and at the New School for Social Research confirmed an interest in reform and progressive education acquired from her mother. After teaching at a progressive school, she traveled to Europe in 1932, where she briefly studied dance and then photography in Berlin and Vienna, until the economic depression and Hitler's growing influence forced her to return home. After working as a freelance photographer from 1934 to 1937—during which time she briefly served as the still photographer in a project at the Highlander Folk School for which her friends Ralph Steiner, Elia Kazan, and Paul Strand were filming southern labor organizing in *People of the Cumberlands*—she was hired by the *Philadelphia Evening Bulletin* as a staff photographer. It was Paul Strand who introduced her to Roy Stryker in 1938. Her reputation as a photographer rests securely on the work she did for the FSA from 1938 until she retired from the agency in 1941 shortly after her marriage to Leon O. Wolcott. After leaving the FSA, her photography became more private, focusing primarily on her children and their friends, although she recorded vividly the people and the worlds they lived in while traveling with her husband to the Middle East in the 1960s. From 1974 until her death she was a freelance photographer in California.

In November of 1938, shortly after she joined the FSA, Stryker sent Marion Post on a trip alone through the South from which she did not return to Washington until mid-July of 1939. She arrived in Charleston and Columbia in December of 1938 on her way down the East Coast and was back in South Carolina on her return trip, photographing the resettlement community of Ashwood Plantation in May, FSA clients Pauline Clyburn and her children in Manning and Frederick Oliver and his family in Summerton in June, and attending the Fourth of July celebration at Frogmore on St. Helena Island. Nearly two hundred photographs of South Carolina are part of the FSA collection from this trip.[25]

JACK DELANO (1914-)

Jack Ovcharov, born in Kiev, Russia, immigrated to the United States as a boy, studied violin, viola, and composition at the Curtis Institute Settlement Music School, and changed his name to Jack Delano while a student at the Pennsylvania Academy of Fine Arts. While traveling in Europe on a music fellowship, he bought a camera to keep a record of the places he had visited, and thus began a career in the visual rather than the performing arts. His first serious photographic project was underwritten by the Federal Arts Program, from which he received support to document the bootleg coal miners who eked a living out of the closed coal mines of the anthracite coal region of Pottsville, Pennsylvania. The resulting show in the Pennsylvania Railroad Station in Philadelphia caught the attention of Paul Strand, who brought the young photographer's work to the attention of Roy Stryker. In April, 1940, Stryker offered Delano a job with the FSA when Arthur Rothstein left the Historical Section to work for *Look* magazine. Delano stayed with the agency through its transfer to the OWI, until he was drafted in 1943. His work for Stryker included a trip of several months to Puerto Rico just before the bombing of Pearl Harbor in 1941. His task was to provide documentary photography for a report being prepared for Congress by the govenor of the island. This was the only assignment outside the continental forty-eight states for any FSA photographer. Delano and his wife Irene fell in

25. F. Jack Hurley, *Marion Post Wolcott: A Photographic Journey* (Albuquerque: University of New Mexico Press, 1989); Walsh and others, *Contemporary Photographers*, pp. 606-607.

love with the island and its people, returning in 1946 on a Guggenheim fellowship to photograph the people for a book. Coincidentally, the governor of Puerto Rico in 1946 was Rexford G. Tugwell, the man who had created the Historical Section of the FSA and invited Roy Stryker to head it. Delano has remained in Puerto Rico ever since, working as director of programming and general manager of Puerto Rican Educational Television, as an independent filmmaker, and as a music teacher at the Puerto Rico Conservatory.

After a long trip in New England during the fall of 1940 as his first assignment, Delano was sent south by Stryker in the spring of 1941. He spent most of March traveling around South Carolina, recording the expulsion from their land and relocation of hundreds of tenant farmers caused by the building of Santee Cooper Dam and the creation of Camp Croft for military training in the Spartanburg area. He recalls vividly the shock of encountering both racial prejudice and a way of life tied closely to tilling the soil, both of which were alien to a young man who had grown up on the paved streets of immigrant neighborhoods of Philadelphia. Delano returned to South Carolina for the Office of War Information on a very different mission in July of 1943, completing picture essays about a South Carolina soldier on leave visiting his family in Bowman, and the activities of Air Service Groups stationed near Greenville and Myrtle Beach. Exhibits of his work in Charleston in 1977 and in Columbia in 1990 brought Delano back to the state as an honored guest speaker, and allowed him to return to the Santee Cooper region to see again the areas he had photographed half a century earlier.[26]

26. Walsh and others, *Contemporary Photographers*, pp. 189-190; Hurley, *Portrait of a Decade*, pp. 148 152; Jack Delano, *Puerto Rico Mio* (Washington, D.C.: Smithsonian Institution Press, 1990).

ARNOLD EAGLE (1909-)

Like Jack Delano, Arnold Eagle was born in Europe, immigrating to New York in 1929 when intensifying anti Semitism made life intolerable for Jews in his native Hungary. He was introduced to photography when he was hired by a photographic studio as a photo retoucher, bought his first camera, a second-hand Graflex, in 1932, and by 1934 had begun a personal documentary project of recording what he feared would be the disappearing culture of Orthodox Judaism in New York. In 1935 he became a photographer for the Works Progress Administration, documenting the slums of New York under the title *One Third of a Nation*. From 1939 to 1940 he photographed unemployed young men and women for the National Youth Administration before turning to freelance photography, making contributions to *Fortune* and the *Saturday Evening Post*. His varied background provided the ideal mixture of the curious eye and the competent technical ability that Stryker needed for the wide-ranging and ambitious undertaking of the Standard Oil of New Jersey photographic project. Although many of Eagle's photographs for Standard Oil were produced in New York, Stryker also sent him to the Northwest and to South Carolina to photograph the lumber industry. As did many other Standard Oil photographers, Eagle was able to continue some freelance work when his travel for Stryker allowed, and from 1944 to 1954 he photographed all aspects of the work of the Martha Graham Dance Company. Since 1955 he has been a teacher of photography at the New School for Social Research in New York.[27]

27. Gallery Guide to exhibit, *Arnold Eagle's New York: The Thirties and Forties*, International Center of Photography, 1990.

TODD WEBB (1905-)

A midwesterner born in Detroit, Michigan, and educated in public schools in Ontario and at the University of Toronto, Todd Webb studied photography at an Ansel Adams workshop in Detroit in 1940. During World War II, he served as a naval photographer's mate in the South Pacific. He returned to civilian life as a freelance photographer whose preference for large-format cameras with "slow" lenses produced documentary photographs of particular places with great clarity but few people, and was hired by Stryker for several Standard Oil shooting projects between 1947 and 1949. Although he made more than three thousand photographs for SONJ that captured the precise qualities of sometimes visually complex locales, his stay in South Carolina in November of 1948 was brief, and like that of Walker Evans with the FSA, concentrated on buildings and highway signs for his documentary subject matter. From 1949 to 1953 Webb lived in France, where he continued his freelance career, completing photographic assignments for several mass-circulation magazines as well as for the World Bank, the World Health Organization, and the United Nations. He continued to do photographic work for the United Nations on his return to New York from 1954 to 1969.[28]

MARTHA MCMILLAN ROBERTS (1920-)

Martha Roberts was raised in Tennessee, attended the University of Tennessee briefly, and then studied painting with Josef Albers at Black Mountain College, an experimental school in North Carolina. It was Albers who provided her with her first camera, a Leica, and introduced her to the documentary artistic medium in which she made her subsequent career. As an apprentice technician in the FSA darkroom during the last years of its existence under Stryker, Roberts met a number of the FSA photographers, and was encouraged by Stryker to gain experience with a camera by working as a news photographer. After a brief time in the Washington bureau of the *Chicago Sun*, and working for a news service, Roberts joined the staff of the War Food Administration, which sent her into the South to document wartime food production activities there. By the time she applied to Stryker for a position on his Standard Oil photographic team, she had thus acquired a wide range of experience and was familiar with the processes and difficulties of carrying out photographic assignments in the South. She remained on the Standard Oil payroll from 1946 until 1949. Stryker sent her regularly into the South to document the cotton industry and its mechanization, and in the fall of 1948 her task was to look closely at the small cotton farms of South Carolina. The photographs that she made in the Aiken and Columbia areas of the state illustrate how little mechanization had affected the Palmetto State's main crop by that time. Her photography here seems to be consciously patterned on some of the visual lessons of earlier photographers for the FSA, including striking images of churches that might have been photographed a decade earlier by Walker Evans. Roberts continued as a freelance photographer when her work for Stryker at Standard Oil ended, teaching photography in Washington, D.C., at the Institute of Contemporary Arts, acting as a photographic consultant for the Kennedy Administration's Commission on Youth, and carrying out photographic assignments in the 1960s and 1970s for the United Mine Workers and the AFL-CIO Regional Council.[29]

28. Walsh and others, *Contemporary Photographers*, pp. 798-99; Plattner, *Roy Stryker*, p. 97.

29. Plattner, *Roy Stryker*, p. 89.

The
Photographs

All of the photographs are printed from original negatives created by the photographers of the Farm Security Administration, the Office of War Information, and Standard Oil of New Jersey. The Library of Congress holds the photographs of the Farm Security Administration and the Office of War Information. The Photographic Archives of the Ekstrom Library at the University of Louisville owns the Standard Oil of New Jersey photographs. The captions for the photographs are those given to them by the photographers.

The Faces and Places of Poverty:
Recording the Depression in South Carolina, 1936–1938

The first Farm Security Administration photographers who came to South Carolina—Walker Evans, Carl Mydens, and Dorothea Lange—came in 1936, while the Depression still held the state firmly in its grip. They stayed only briefly, but the images they produced reflect both their individual visions and the paradox of South Carolina's rich historical heritage side by side with a deep-rooted poverty. In the next two years, Marion Post Wolcott came to South Carolina on two extended trips. A former educator particularly sensitive to children, she explored South Carolina's back roads where Farm Security Administration clients struggled with a quiet dignity to overcome poor housing, shortages of food, worn-out soil, and inadequate sanitation and health care.

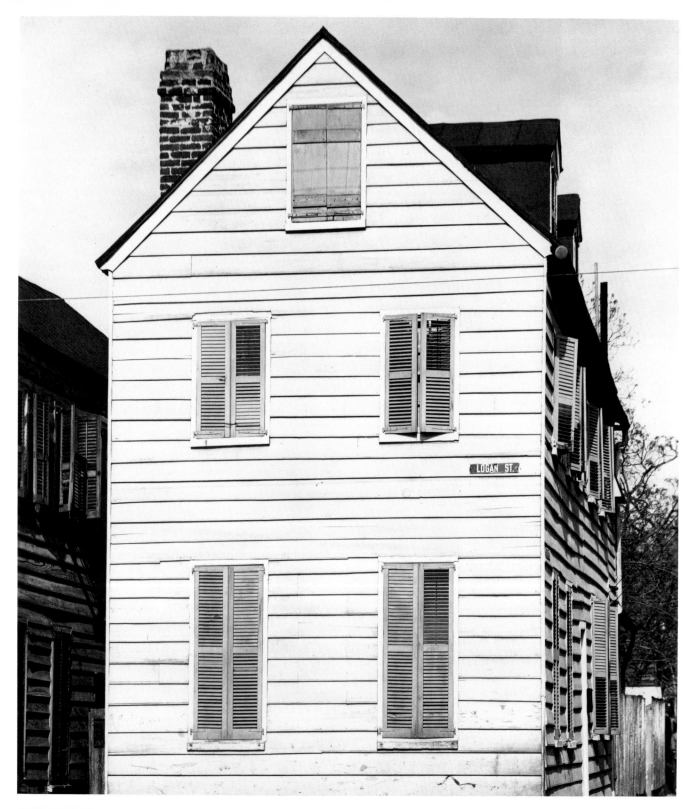

March 1936.
Charleston. A frame house.
WALKER EVANS
LC-USF34 8105

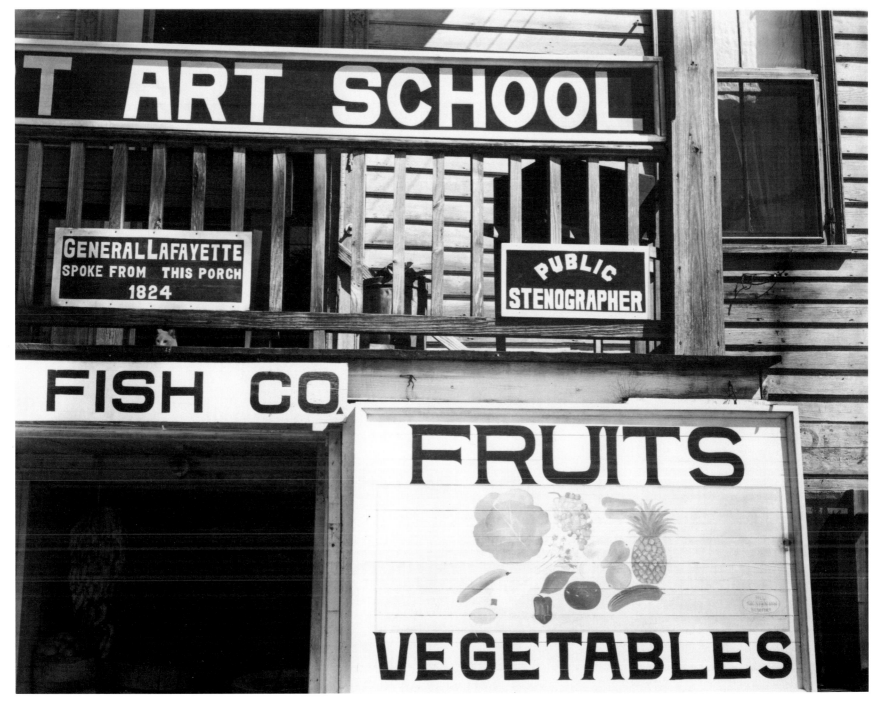

March 1936.
Beaufort. A fruit sign.
WALKER EVANS

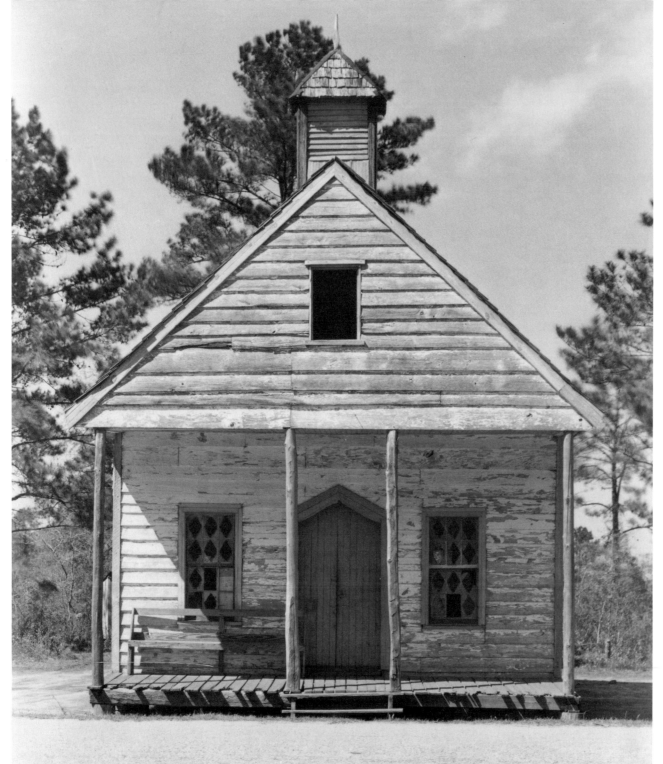

March 1936.
A Negro church in South Carolina.
WALKER EVANS
LC-USF34 8055

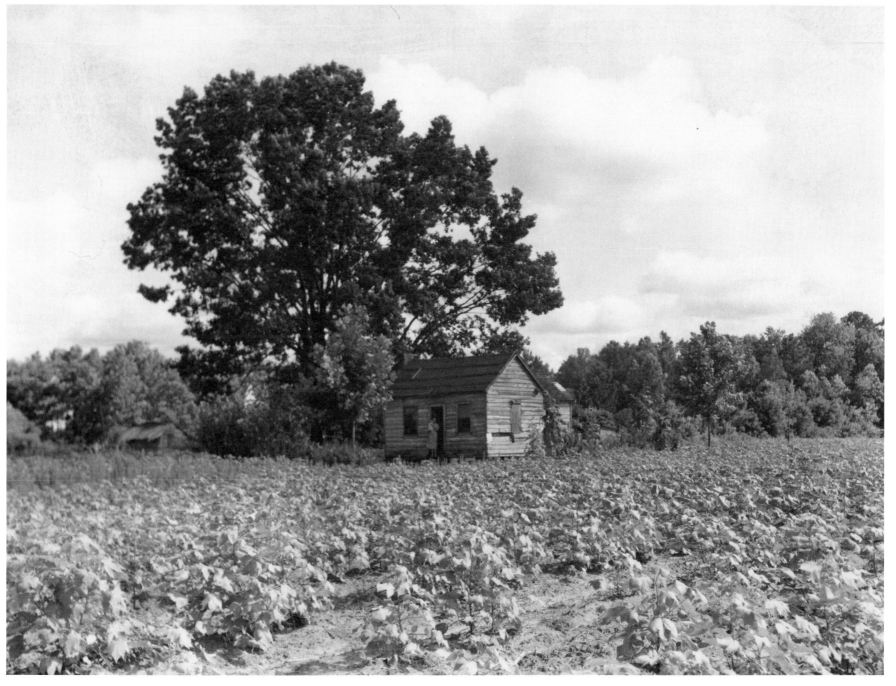

June 1936. Lobeco.
A white tenant farm, a three-room shack
which houses a family of eleven.
CARL M. MYDENS
LC-USF34 6811

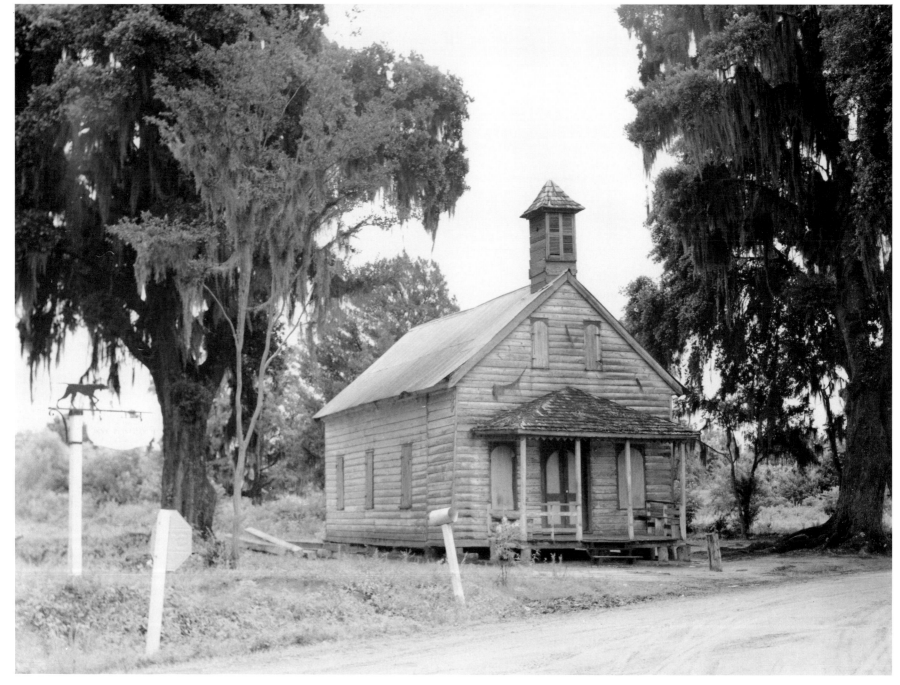

June 1936. Charleston.
A church at a crossroads on Sea Level highway.
CARL M. MYDENS
LC-USF34 6807

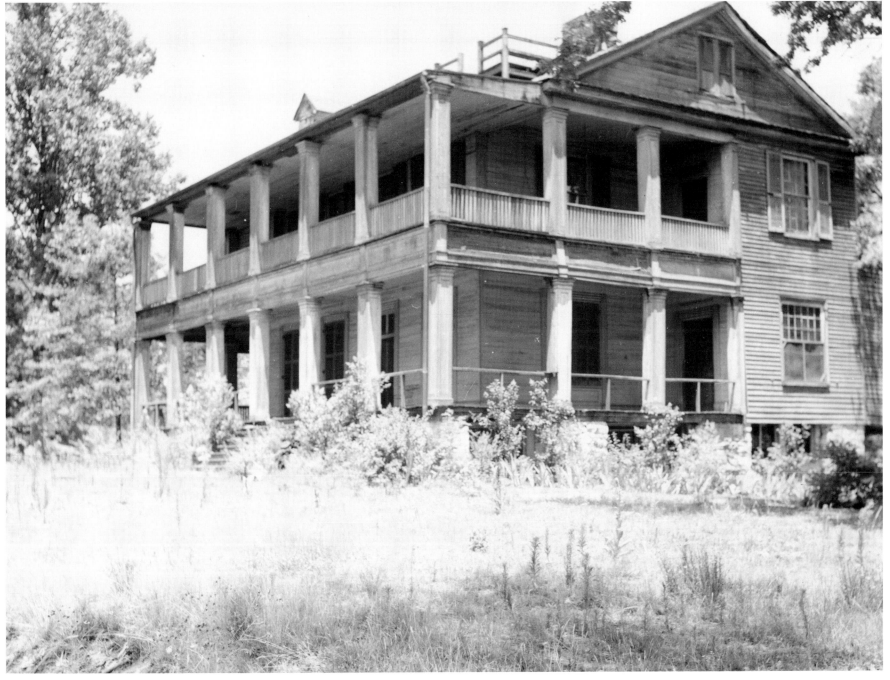

June 1936.
"Woodburn," built shortly after the Revolution by
Charles Cotesworth Pinckney, one of the framers of the Constitution.
CARL M. MYDENS
LC-USF34 6814

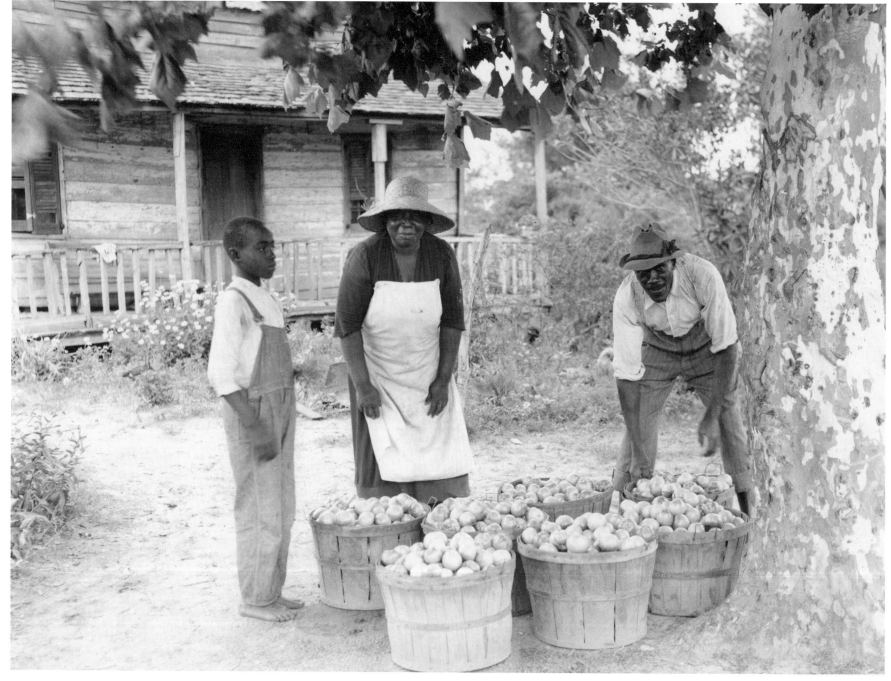

June 1936. Beaufort.
A U.S. Resettlement Administration client
and his wife with one day's tomato pick.
CARL M. MYDENS
LC-USF34 6797

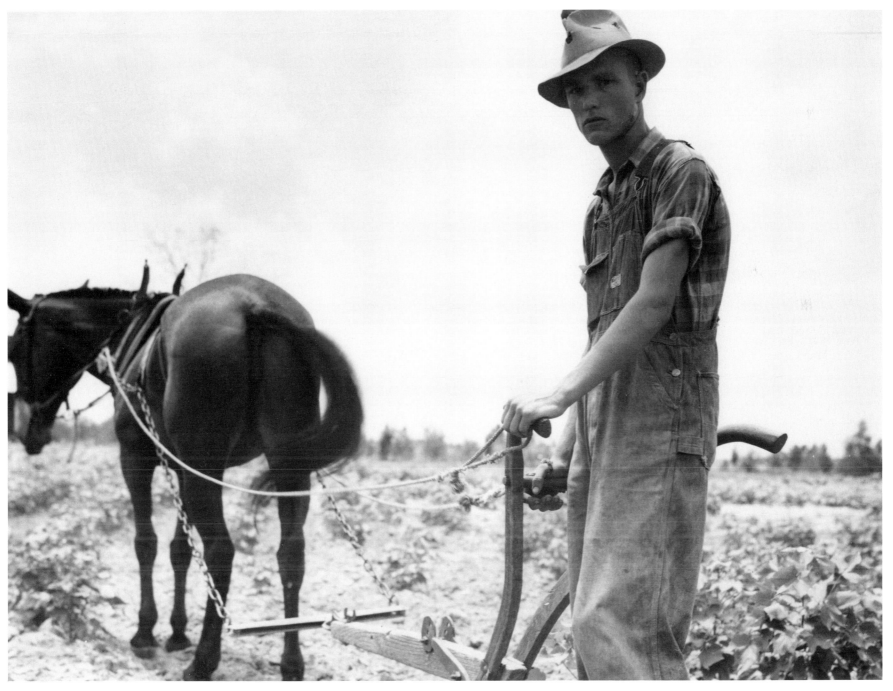

June 1937. Chesnee (vicinity).
The son of a sharecropper family
at work in the cotton field.
DOROTHEA LANGE
LC-USF34 17375

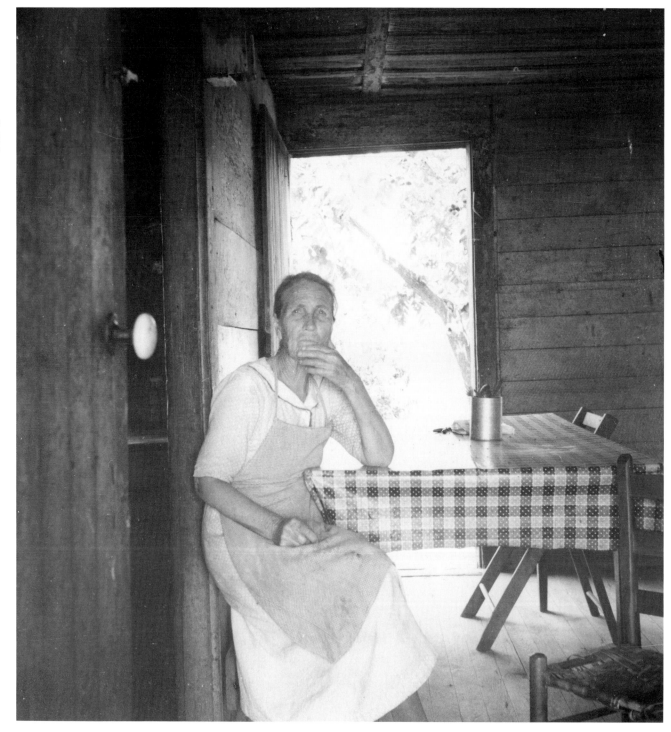

July 1937. Chesnee (vicinity).
A woman who has 10 children
and 56 grandchildren.
DOROTHEA LANGE
LC-USF34 18130

July 1937. Chesnee (vicinity).
A sharecropper boy.
DOROTHEA LANGE
LC-USF34 18142

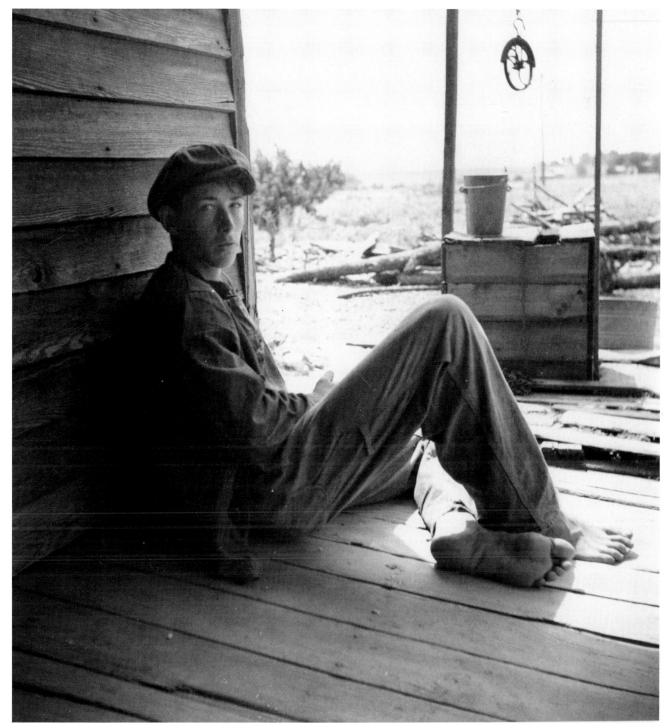

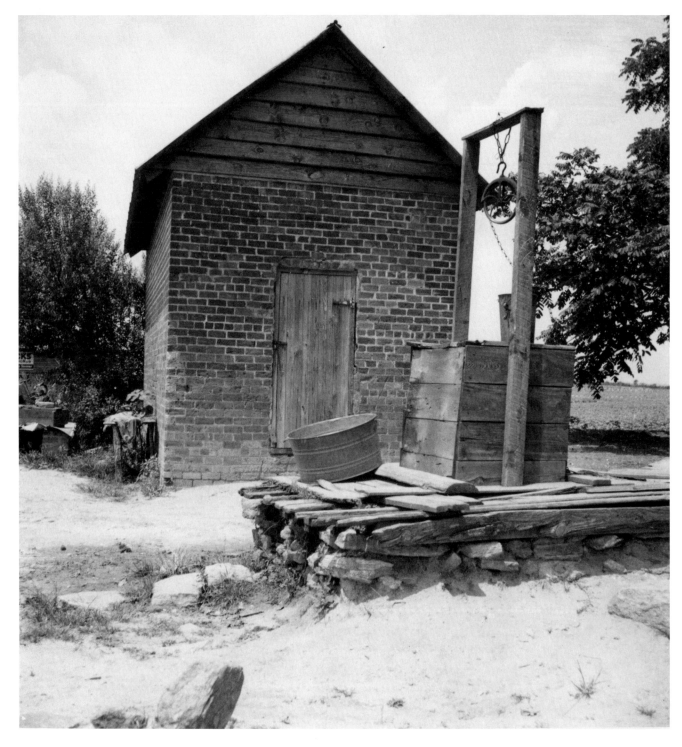

July 1937. Chesnee.
A well and an old plantation
smoke house.
DOROTHEA LANGE
LC-USF34 18133

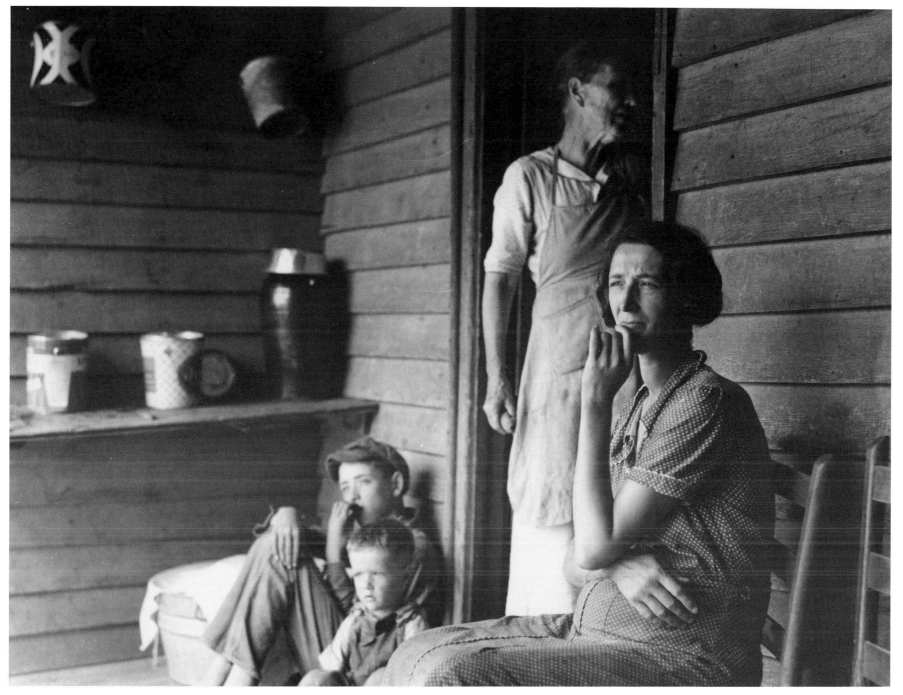

July 1937. Chesnee (vicinity).
The wife and mother of a sharecropper.
DOROTHEA LANGE
LC-USF34 18103

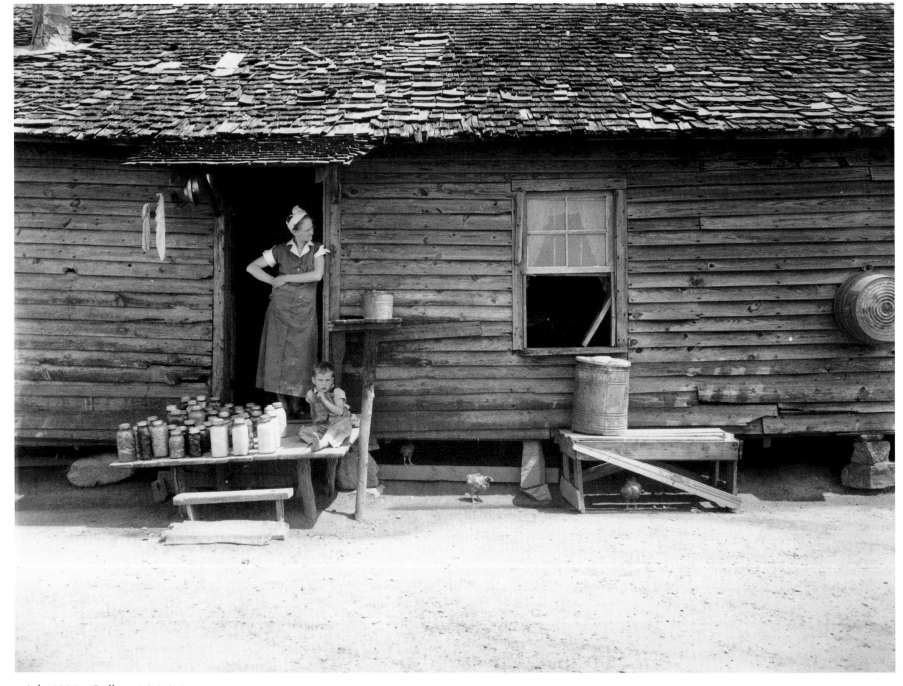

July 1937. Gaffney (vicinity).
The wife and child of a sharecropper. The farmer does a little day labor for his landlord
for which he received 50 cts. a day in 1936 and 60 and 75 cts. a day in 1937.
DOROTHEA LANGE
LC-USF34 18080

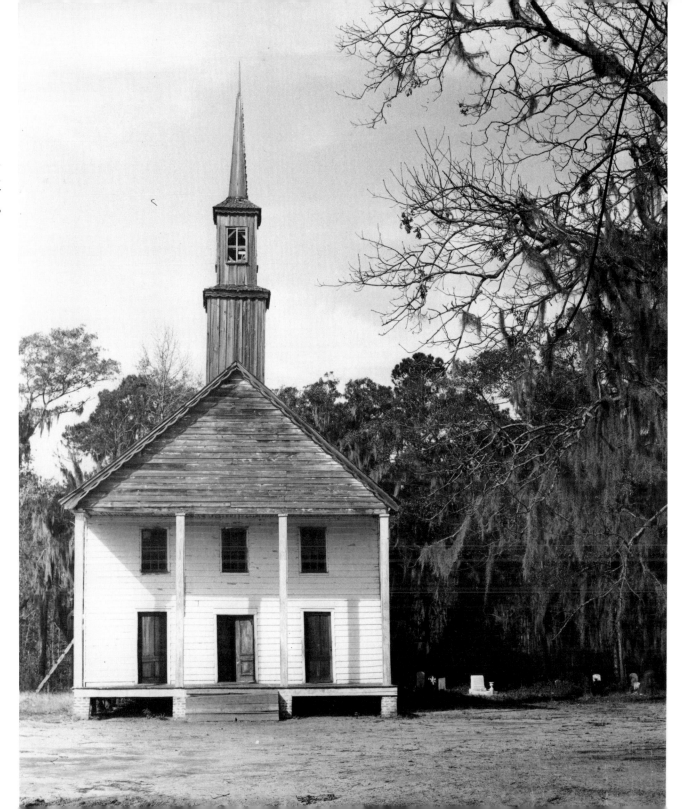

December 1938.
Summerville (vicinity). A church.
MARION POST WOLCOTT
LC-USF34 50446

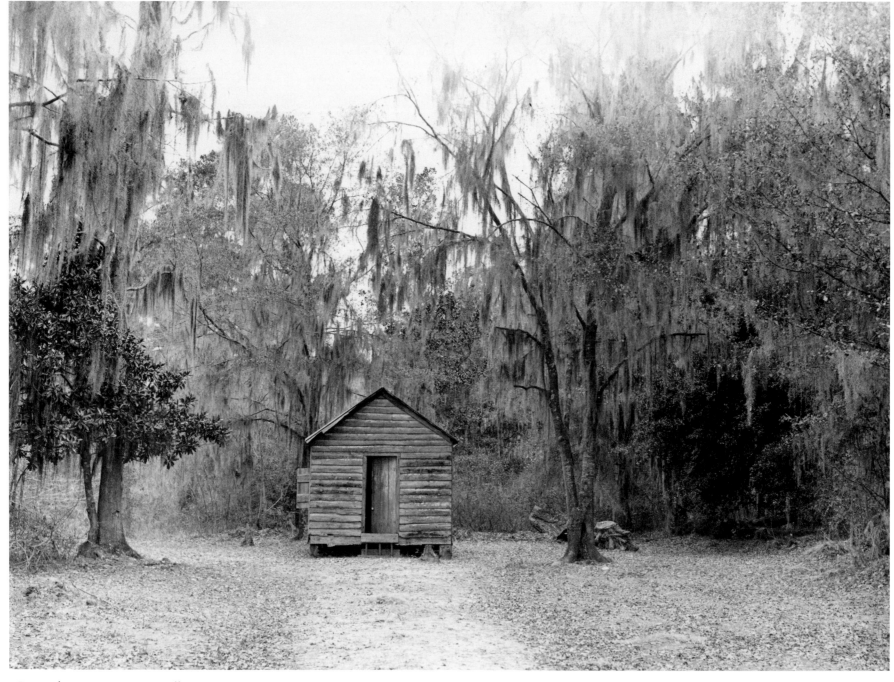

December 1938. Summerville (vicinity).
A Negro school house.
MARION POST WOLCOTT
LC-USF34 50522

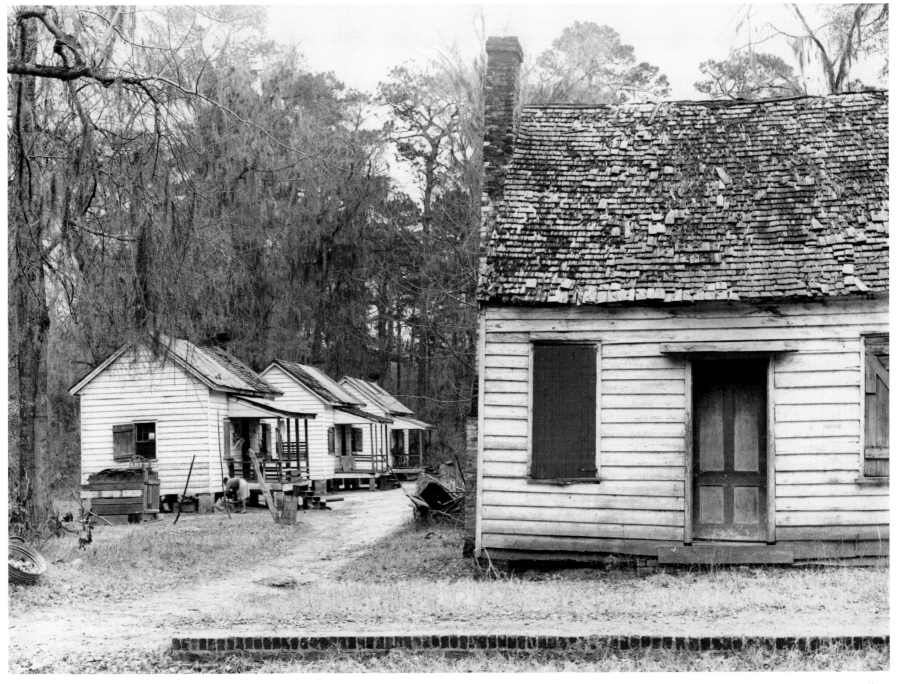

December 1938. Summerville.
Servant quarters in the rear of a home.
MARION POST WOLCOTT
LC-USF34 50598

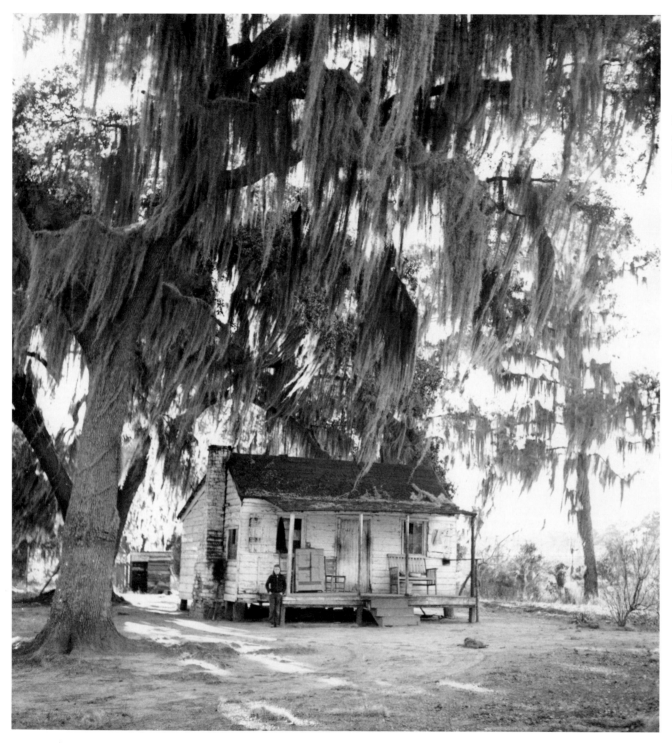

December 1938. Summerville (vicinity).
A cabin which is occupied
by a white family.
MARION POST WOLCOTT
LC-USF34 50833

December 1938. Summerville (vicinity). The home of an Indian (mixed breed) family with a mud chimney.
MARION POST WOLCOTT
LC-USF34 50598

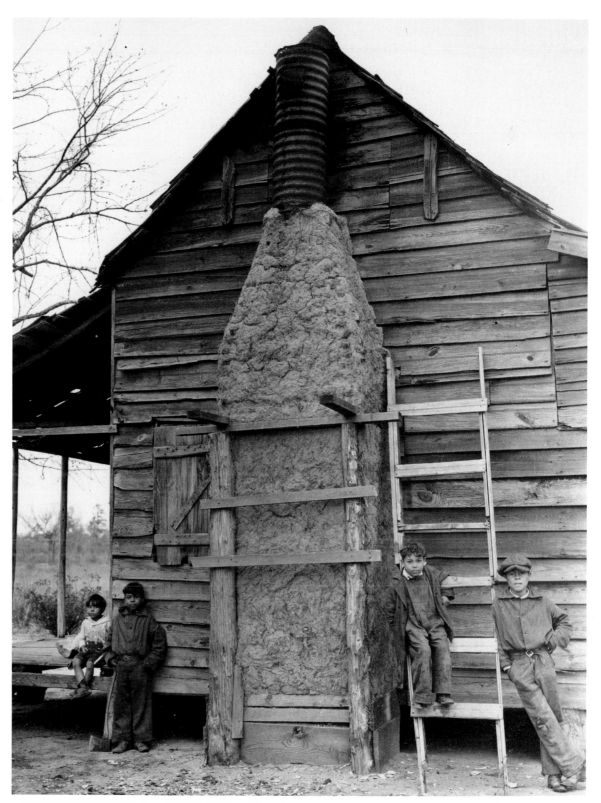

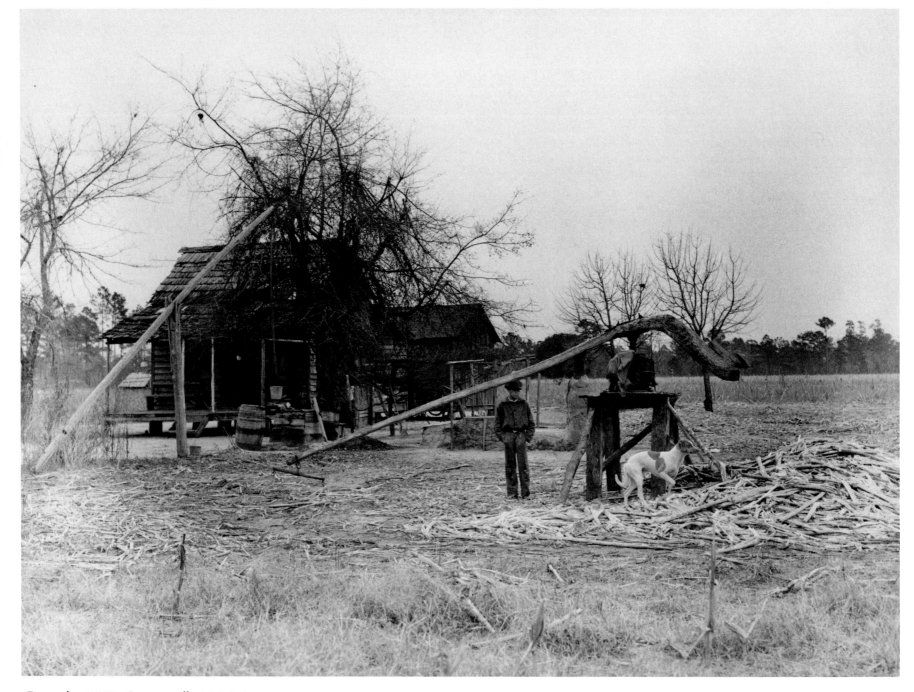

December 1938. Summerville (vicinity).
The home of an Indian (mixed breed) family with a sorghum
cane grinder in the foreground.
MARION POST WOLCOTT
LC-USF34 50463

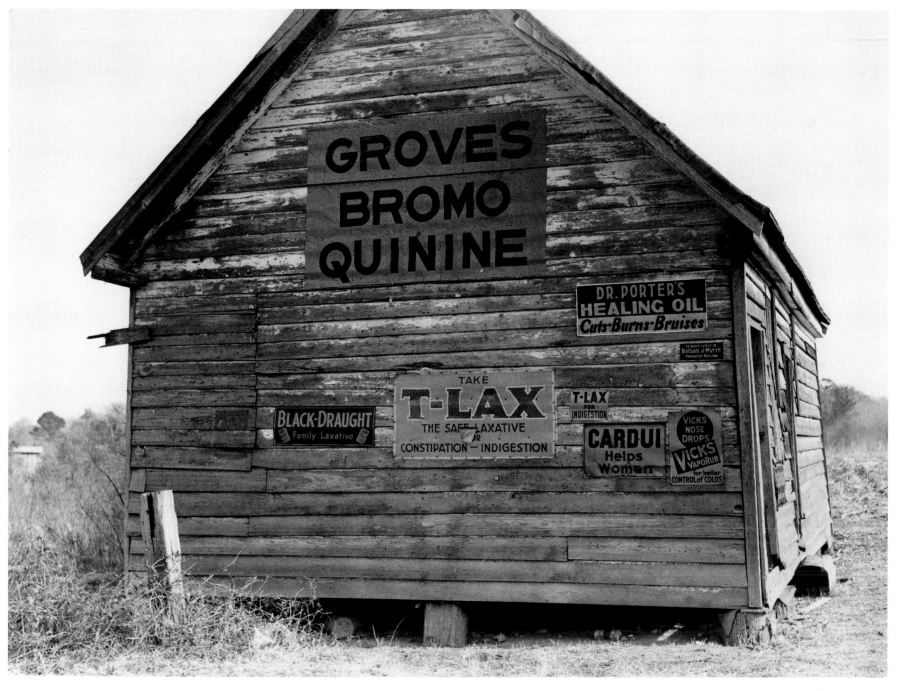

December 1938. Summerville (vicinity).
Advertisements on the side of an old shack.
MARION POST WOLCOTT
LC-USF34 50583

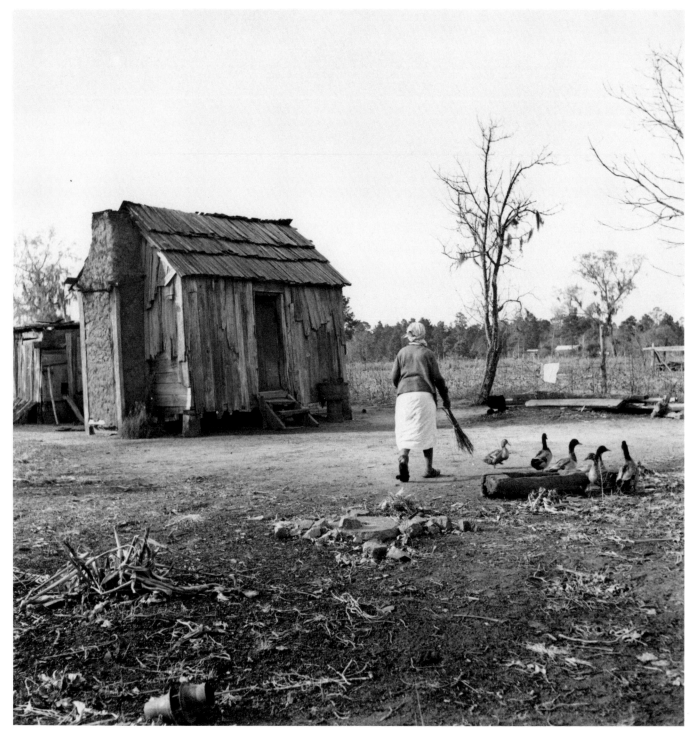

44

December 1938. Beaufort (vicinity).
The home of a Negro.
MARION POST WOLCOTT
LC-USF34 50784

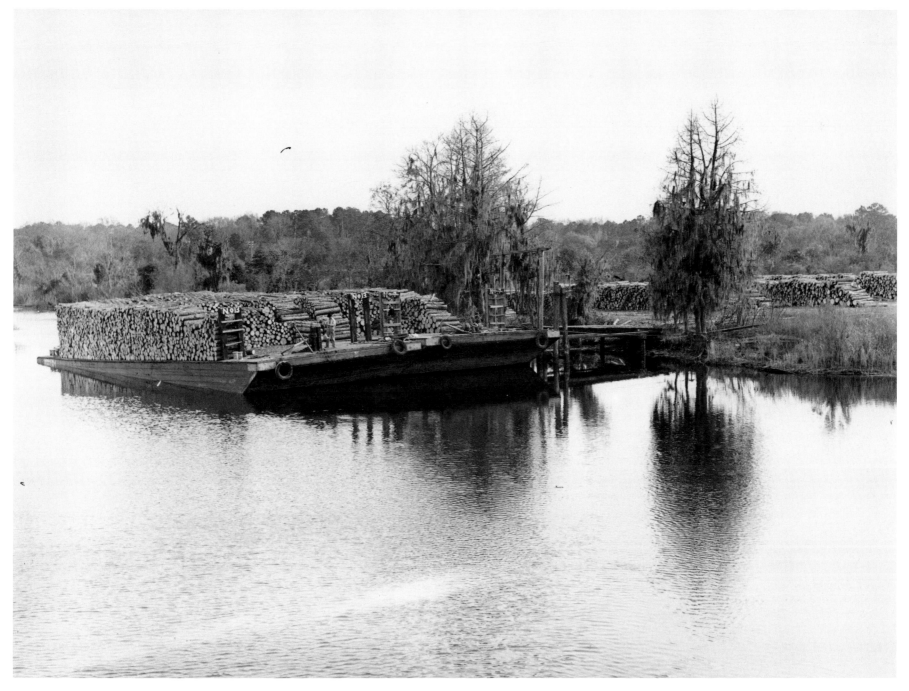

December 1938. Ashepoo.
Logs on a river barge near a sawmill.
MARION POST WOLCOTT
LC-USF34 50547

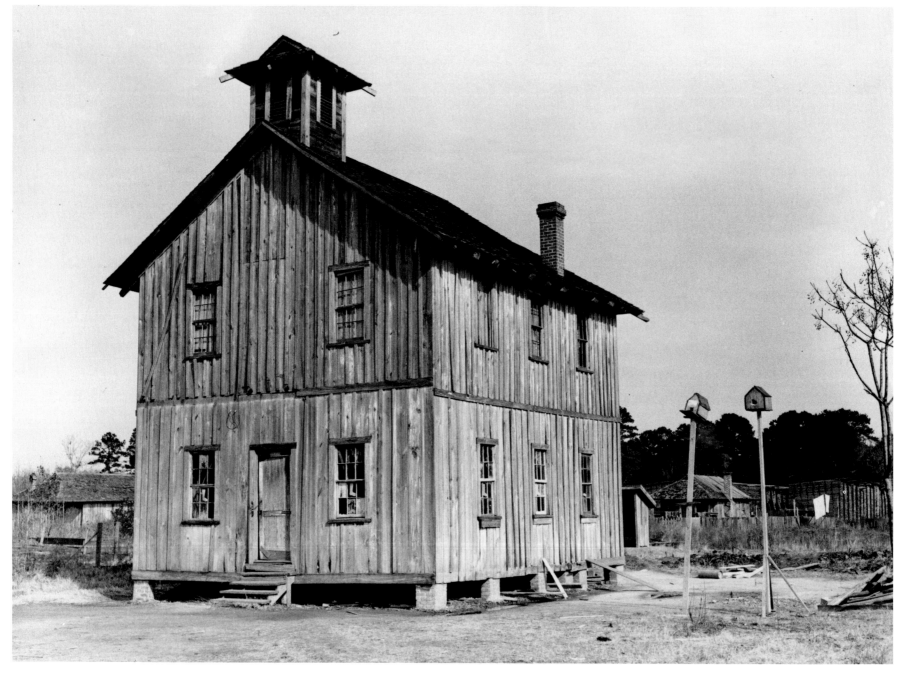

December 1938. Ashepoo.
A school house in a sawmill town.
MARION POST WOLCOTT
LC-USF34 50548

December 1938. Ashepoo.
A gas station and commissary
in a sawmill town.
MARION POST WOLCOTT
LC-USF34 50776

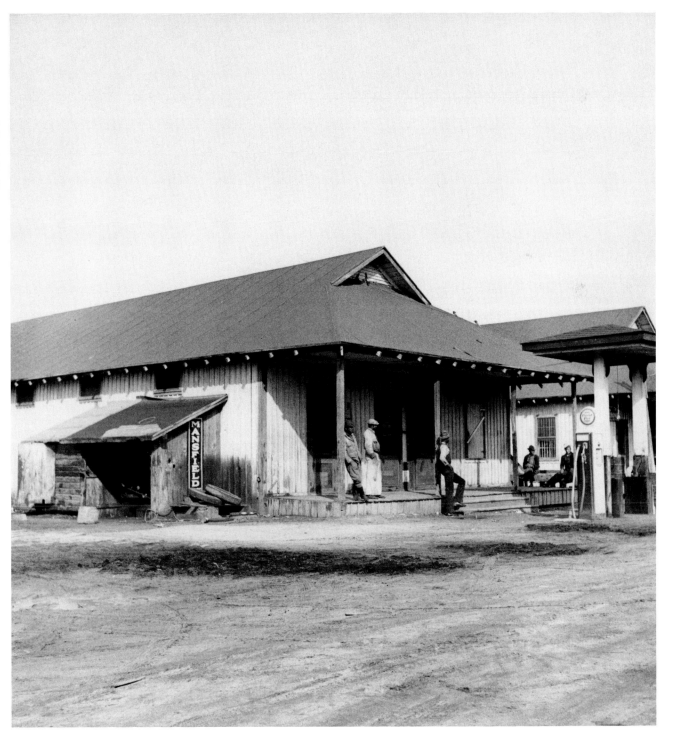

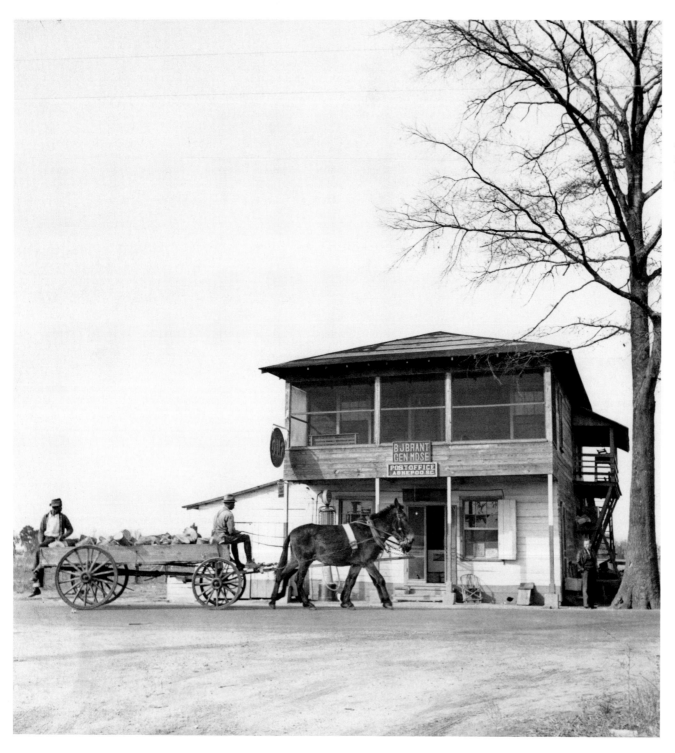

48

December 1938. Ashepoo.
A general store and post office.
MARION POST WOLCOTT
LC-USF34 50755

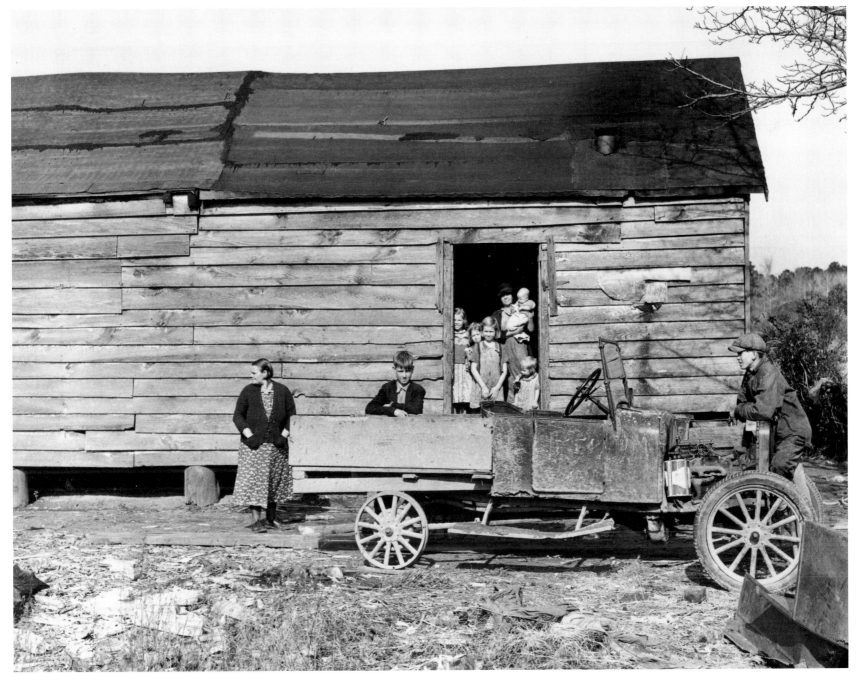

December 1938. Jacksonboro.
A family who is on relief.
MARION POST WOLCOTT
LC-USF34 50587

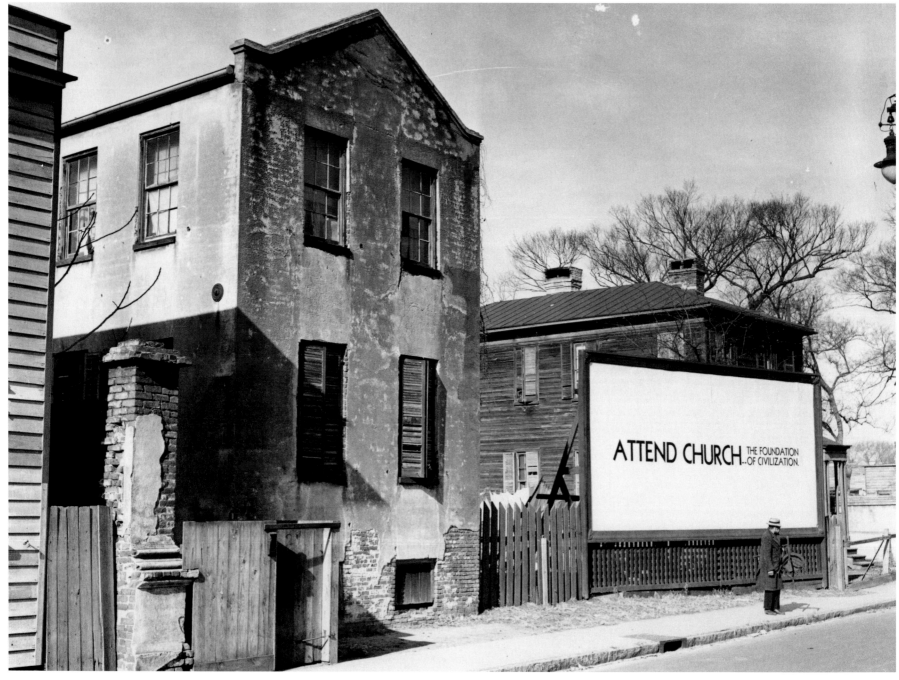

December 1938. Charleston.
A street scene with a church sign.
MARION POST WOLCOTT
LC-USF34 50455

December 1938. Charleston.
A cook on a fishing boat peeling
potatoes for Christmas dinner.
MARION POST WOLCOTT
LC-USF34 50619

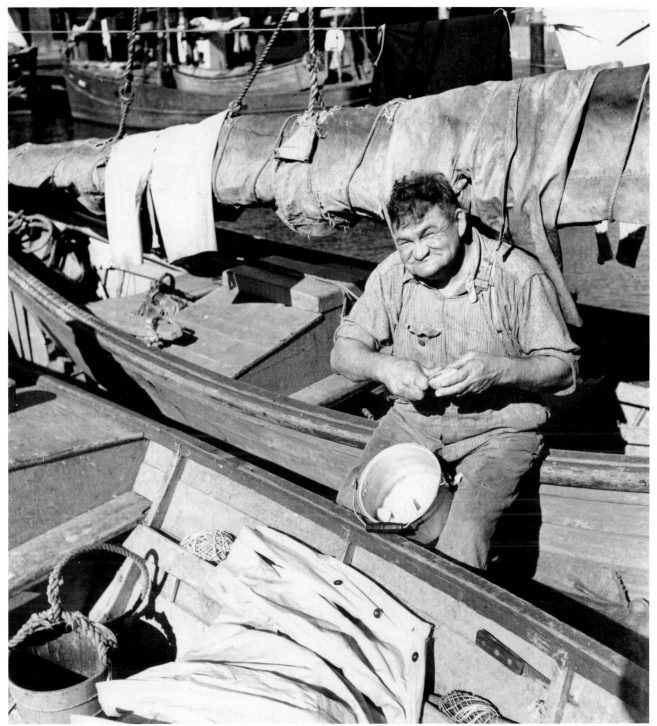

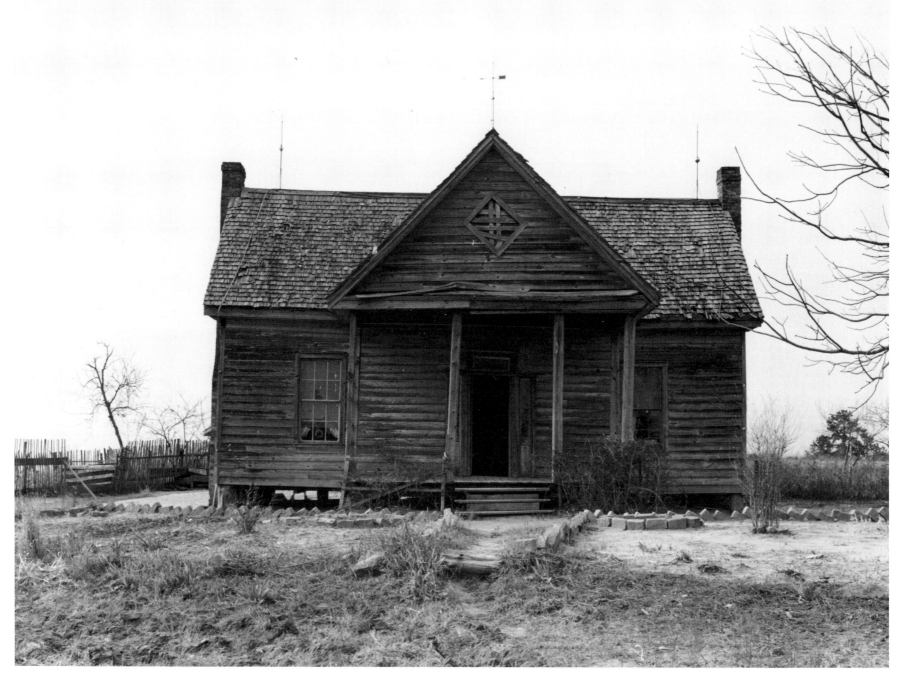

December 1938. Columbia (vicinity).
A house previously owned by white people but which is now
owned by a Negro woman who cannot afford to keep it in repair.
MARION POST WOLCOTT
LC-USF34 50477

Resettlement and Rehabilitation:
New Deal Programs
Make an Impact, 1939-1941

Relocation of families to make room for changes in South Carolina begins and ends this group of Depression-era photographs from the Farm Security Administration. Ashwood Plantation was the most successful of South Carolina's three planned resettlement communities, and the visual record of its celebration of a May "Health Day" illustrates FSA successes. By contrast, those moving out of the lands shortly to be flooded by the waters of Lake Marion in the Santee Cooper basin found resettlement a wrenching experience. When Marion Post Wolcott returned to South Carolina in 1939, Ashwood Plantation was celebrating the completion of the construction of a community center and the establishment of an educational program for its children and youth. The men, women, and children Jack Delano photographed in Bonneau were dismantling rather than rebuilding their lives: taking apart houses, carefully digging up gravesites to remove loved ones to new resting places, saying farewell to lifetimes soon to change. Bracketed between these opposite faces of resettlement gains and pains is a series of images that record the daily impact of rehabilitation programs at work: a farm woman who received a loan has a good crop for her family to help harvest; canning equipment and the knowledge of how to use it properly ensures food for the coming winter; cooperative grants give a farmer a team of horses to work his tobacco.

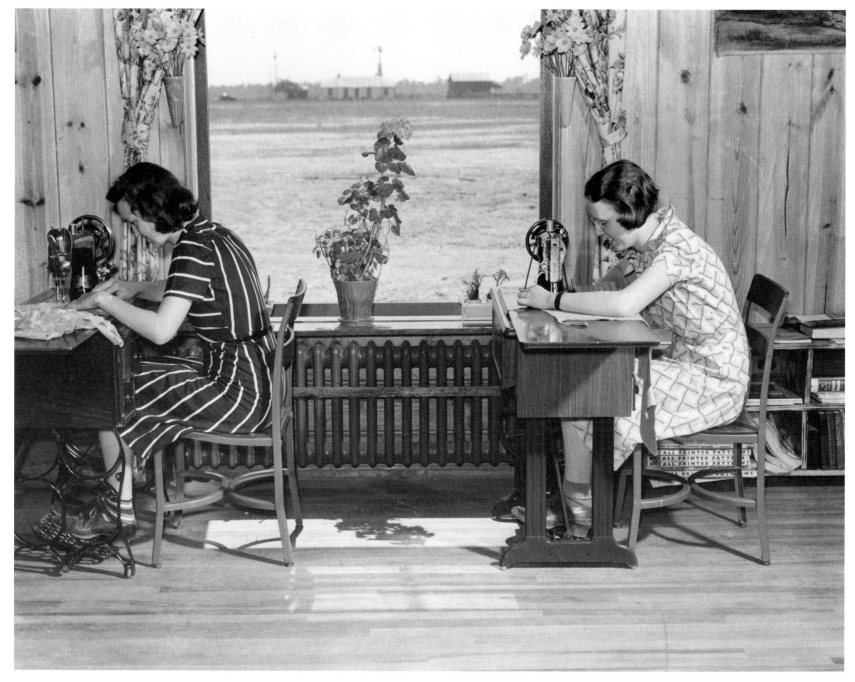

May 1939. Ashwood Plantations, a Farm Security Administration project, near Bishopville.
Jane McCutcheon and Ruth Lee Hoar sewing on sewing machines in the
home economics class room, at the school.
MARION POST WOLCOTT
LC-USF34 51641

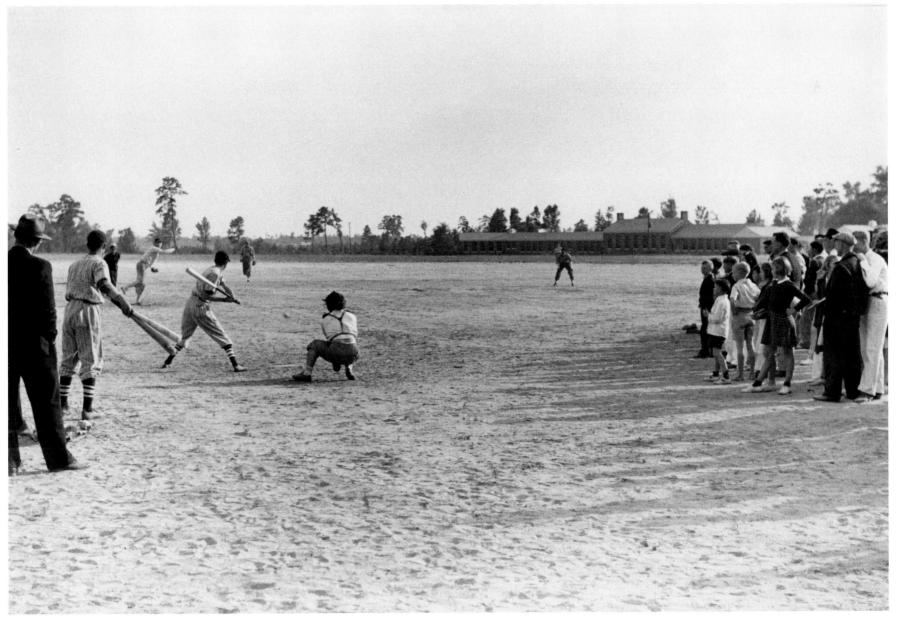

Spring 1939. Ashwood Plantations,
a Farm Security Administration project, near Bishopville.
A baseball game, part of the May Day-Health Day festivities.
MARION POST WOLCOTT
LC-USF33 30369-M2

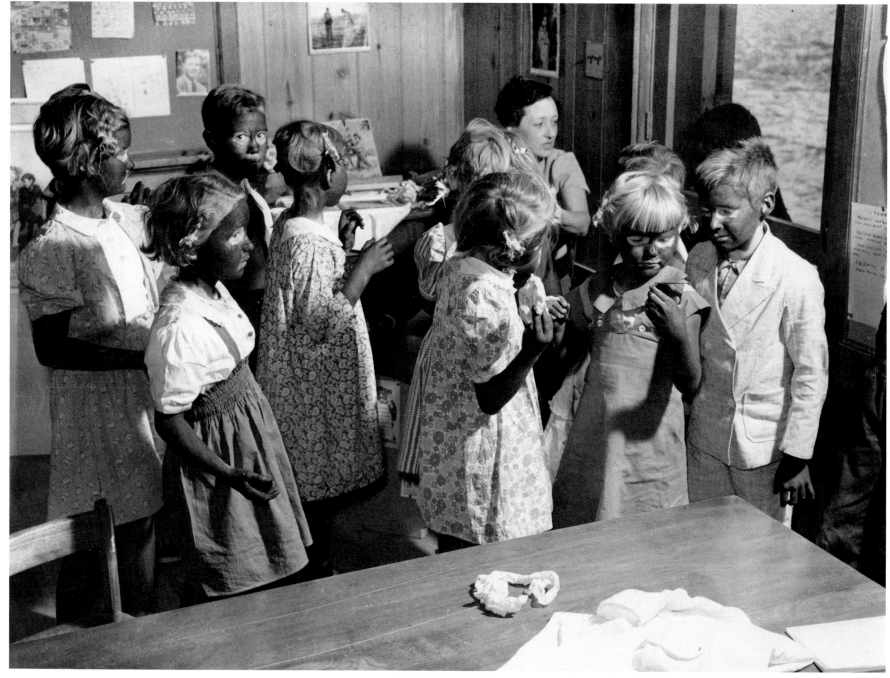

May 1939. Ashwood Plantations, a Farm Security Administration project, near Bishopville.
2nd. and 3rd. grade children being made up for their Negro song and dance the May Day-
Health Day festivities.
MARION POST WOLCOTT
LC-USF34 51676

May 1939. Ashwood Plantations,
a Farm Security Administration project, near Bishopville.
First grade children singing a health song in the May Day-Health Day program.
MARION POST WOLCOTT

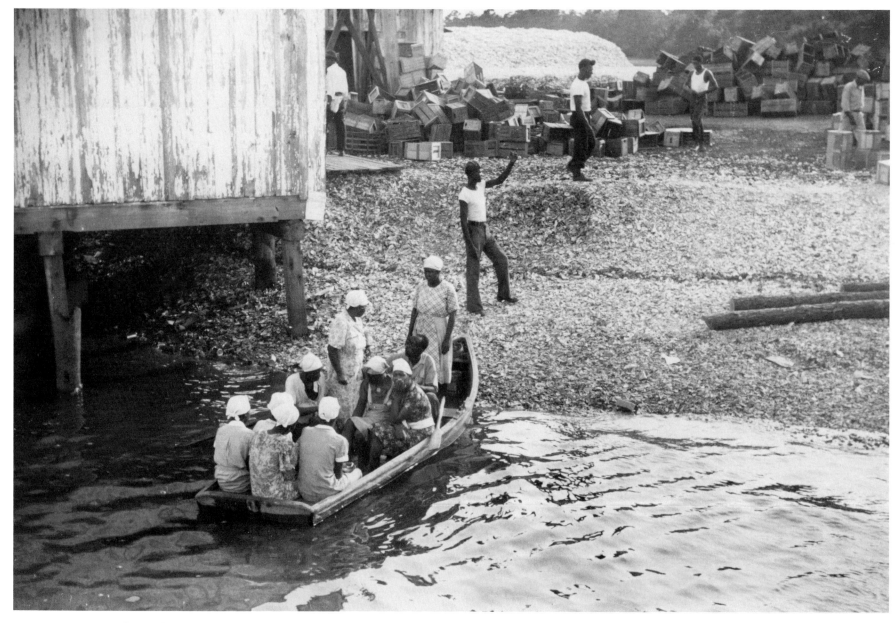

June 1939. St. Helena Island.
Cannery working going home.
MARION POST WOLCOTT
LC-USF33 30430-M1

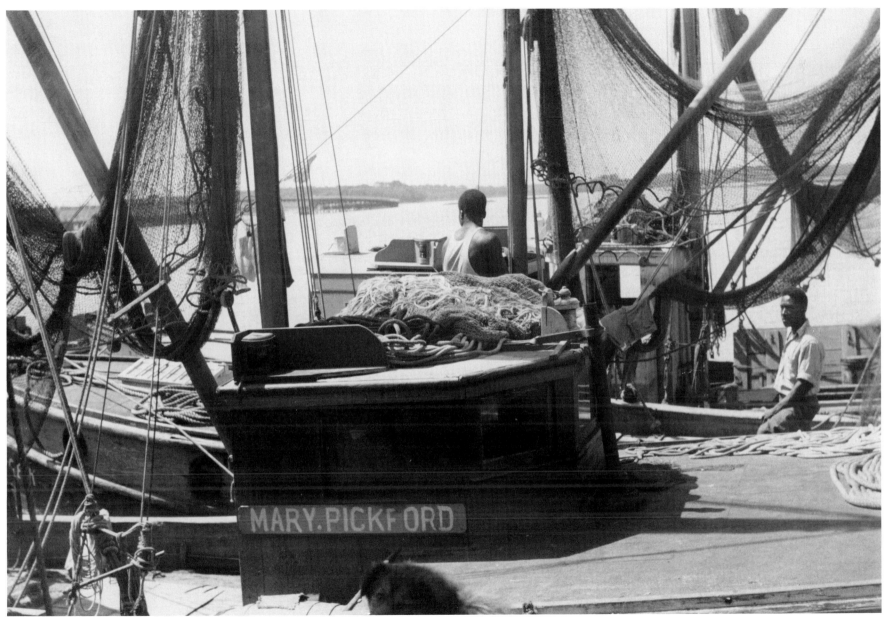

June 1939. St. Helena Island.
Fishing boats.
MARION POST WOLCOTT
LC-USF33 30431-M2

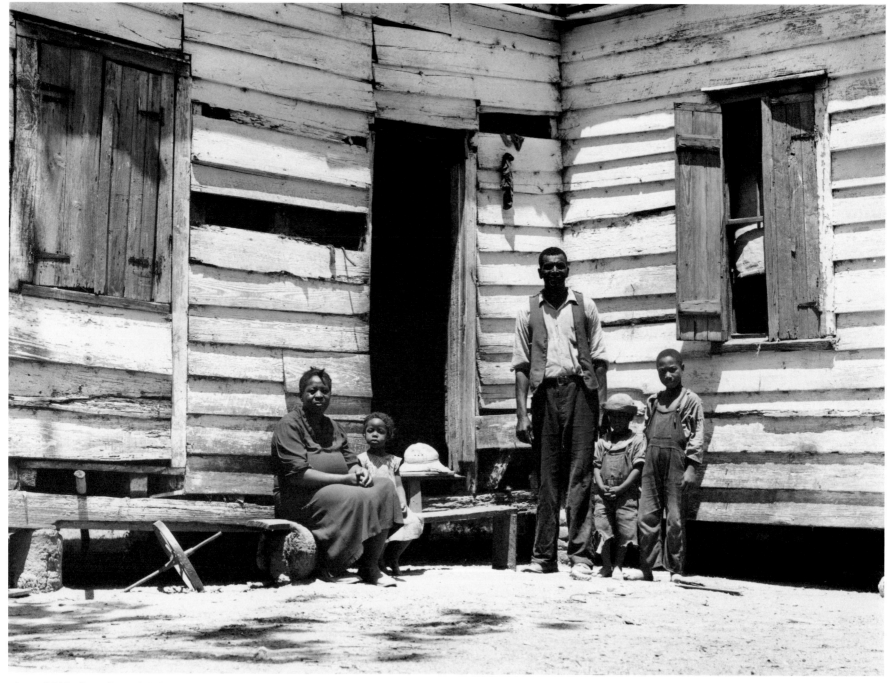

June 1939. Beaufort (vicinity).
The Brown family in front of their home. They pay part of their expenses from the sale of oranges which they
raise on their farm and part from what Mrs. Brown earns working in the oyster beds nearby.
MARION POST WOLCOTT
LC-USF34 51954

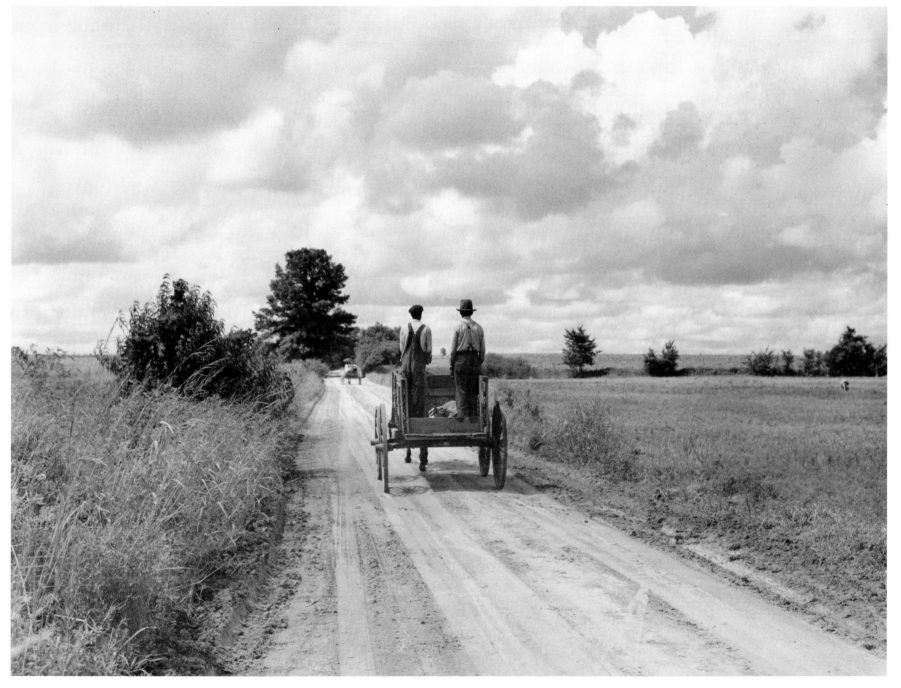

June 1939. Manning (vicinity).
A rural scene.
MARION POST WOLCOTT
LC-USF34 51907

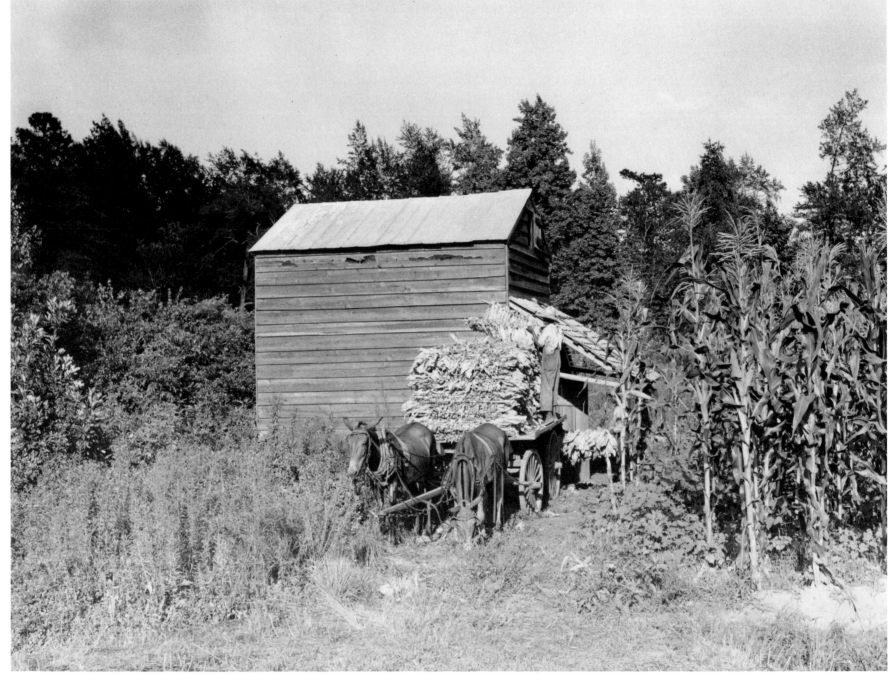

June 1939. Manning (vicinity).
Stringing tobacco before putting the
tobacco in a curing house.
MARION POST WOLCOTT
LC-USF34 51935

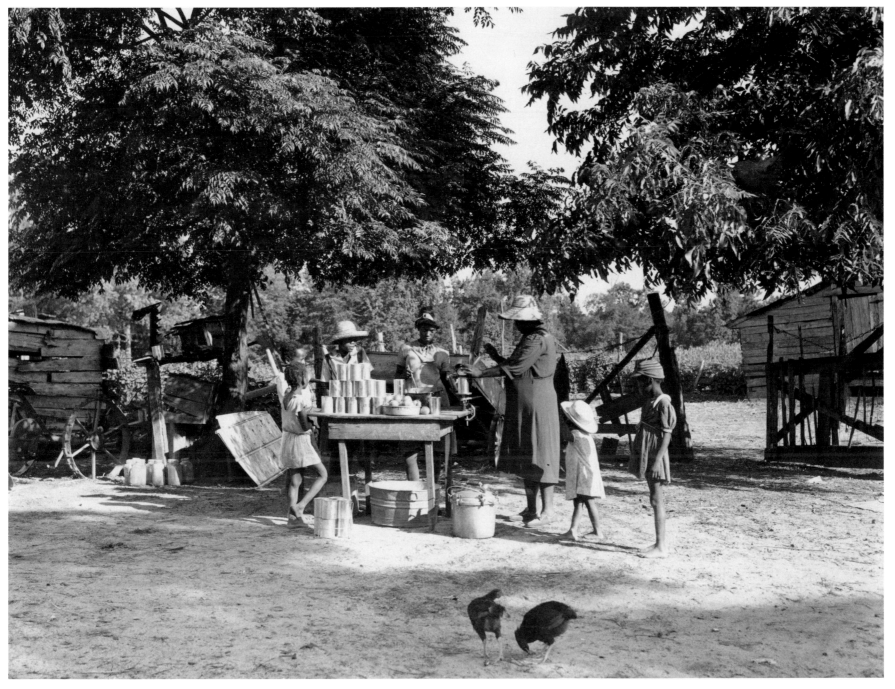

June 1939. Manning .
Pauline Clyburn, a Resettlement Administration
borrower, and her children canning tomatoes.
MARION POST WOLCOTT
LC-USF34 51917

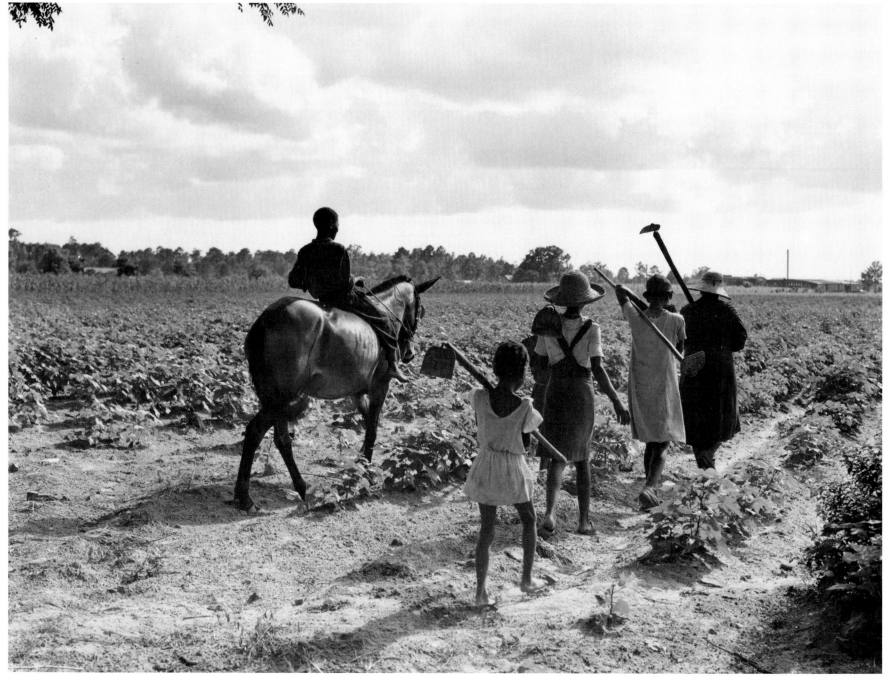

June 1939. Manning.
Pauline Clyburn, a U.S. Resettlement Administration client,
and her children going to the field to chop cotton.
MARION POST WOLCOTT
LC-USF34 51919

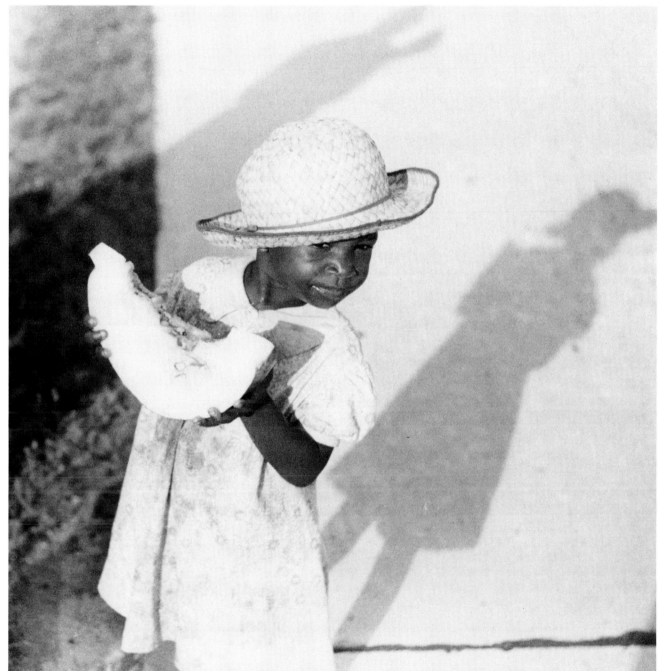

June 1939. Manning.
One of the children of
Pauline Clyburn, a U.S. Resettlement
Administration borrower,
eating watermelon.
MARION POST WOLCOTT
LC-USF32 30495-M5

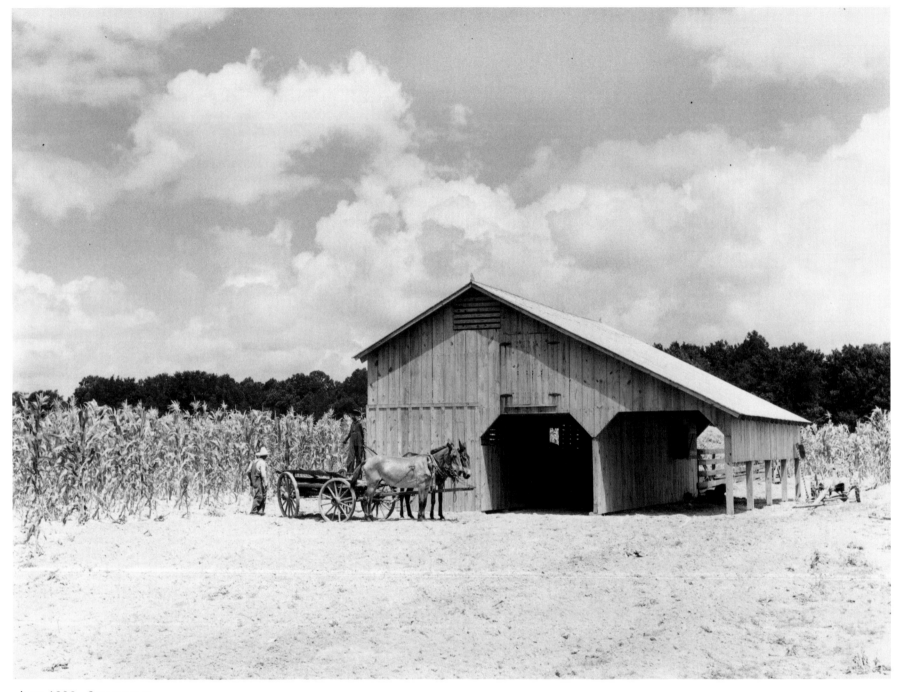

June 1939. Summerton.
Frederick Oliver, a tenant purchase client, back of his barn
with a team of mules which he recently purchased.
MARION POST WOLCOTT
LC-USF34 51941

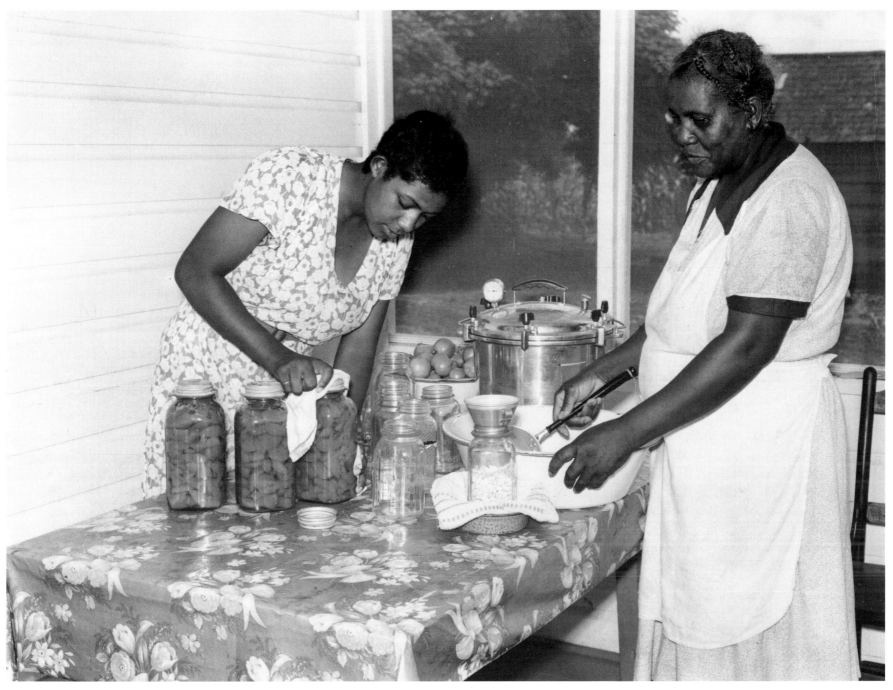

June 1939. Summerton.
The wife and daughter of Frederick Oliver, a U.S. Resettlement
Administration borrower, canning food with the aid of a pressure cooker.
MARION POST WOLCOTT
LC-USF34 51936

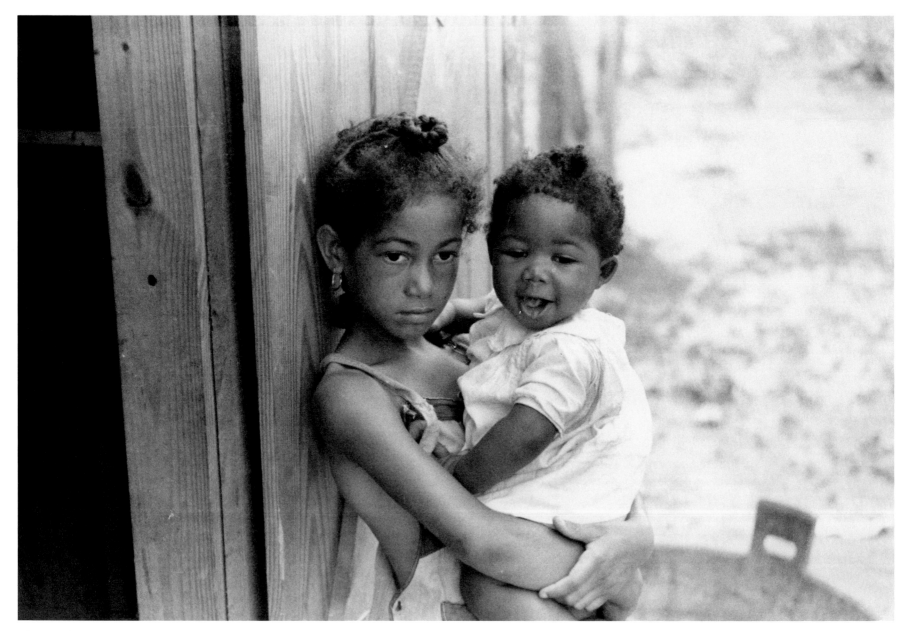

June 1939. Summerton.
The children of Frederick Oliver, a U.S. Resettlement
Administration tenant purchase borrower.
MARION POST WOLCOTT
LC-USF33 30495-M2

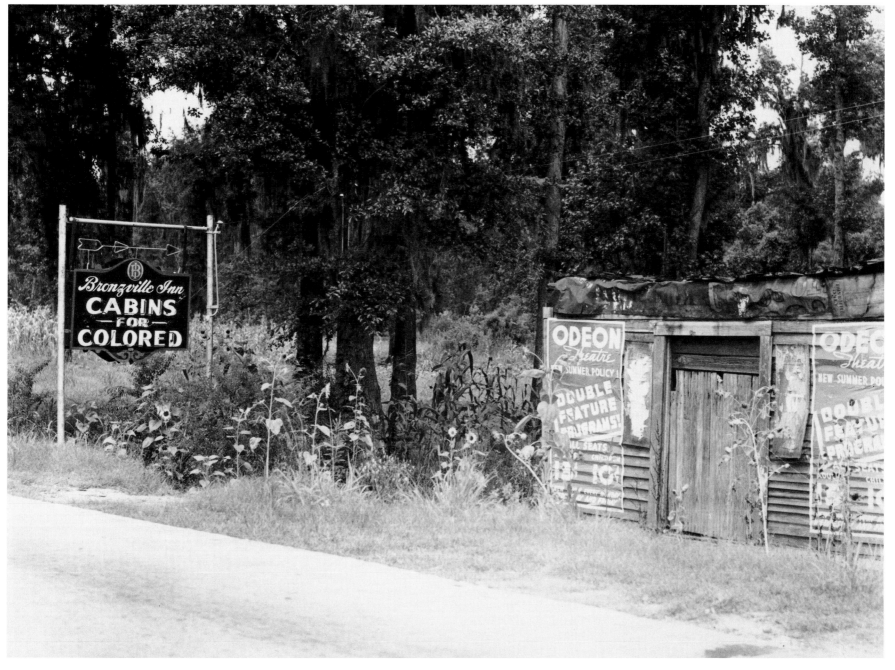

June 1939. Summerton (vicinity).
A highway sign advertising tourist cabins
for Negroes, in South Carolina.
MARION POST WOLCOTT
LC-USF34 51945

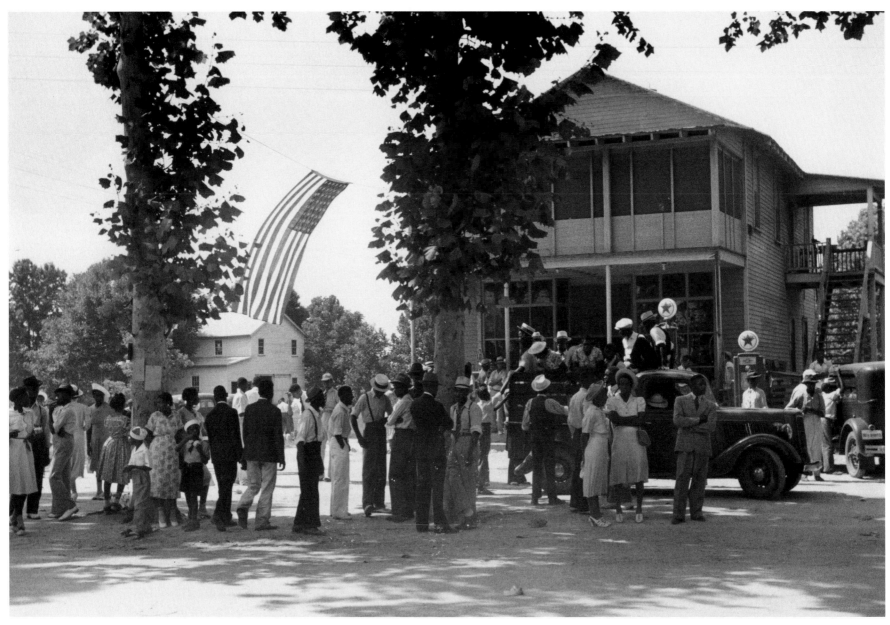

July 1939. St. Helena Island.
A Fourth of July celebration.
MARION POST WOLCOTT
LC-USF33 30417-M1

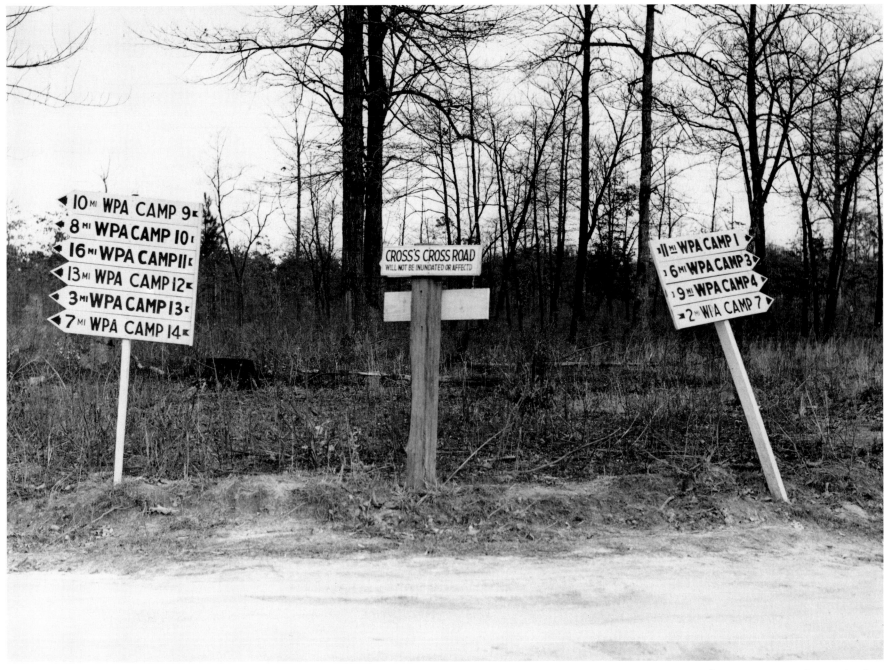

March 1941. Santee Cooper basin.
Works Progress Administration road signs at a crossroads.
JACK DELANO
LC-USF34 43553

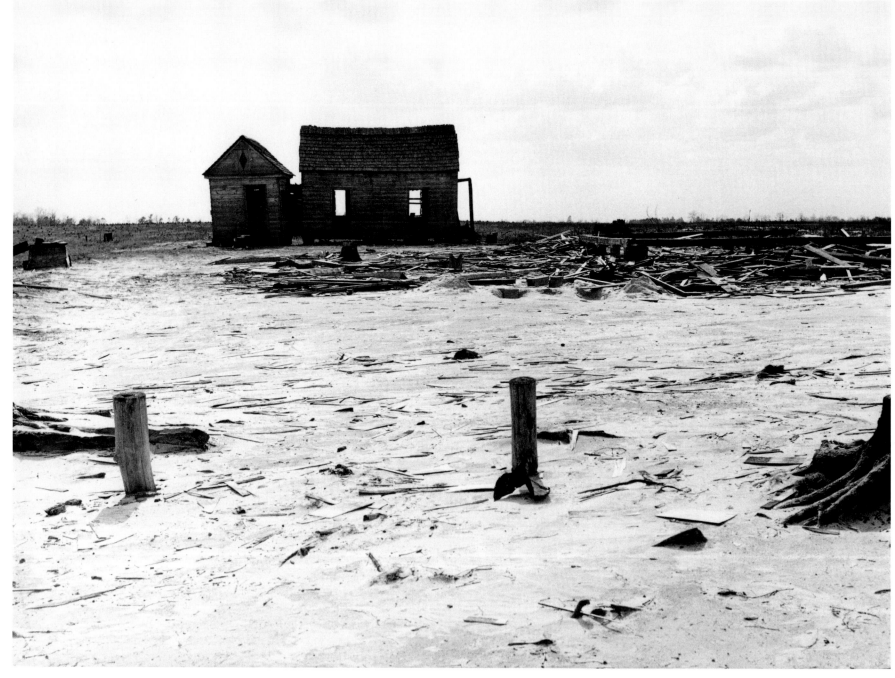

March 1941. Moncks Corner (vicinity).
An abandoned house in the Santee-Cooper basin area.
JACK DELANO
LC-USF34 43570

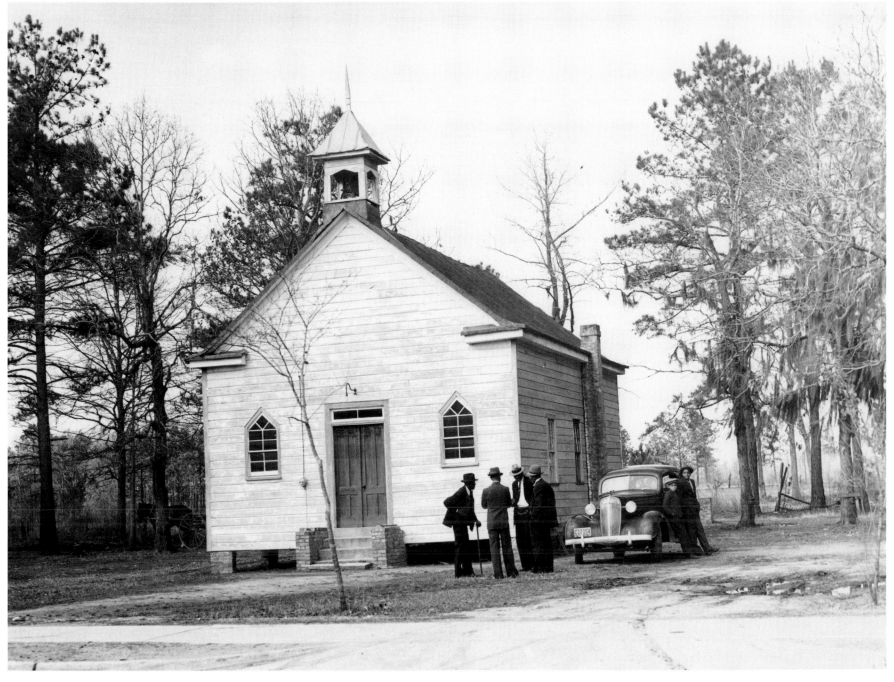

March 1941. Moncks Corner.
A Negro Church.
JACK DELANO
LC-USF34 43460

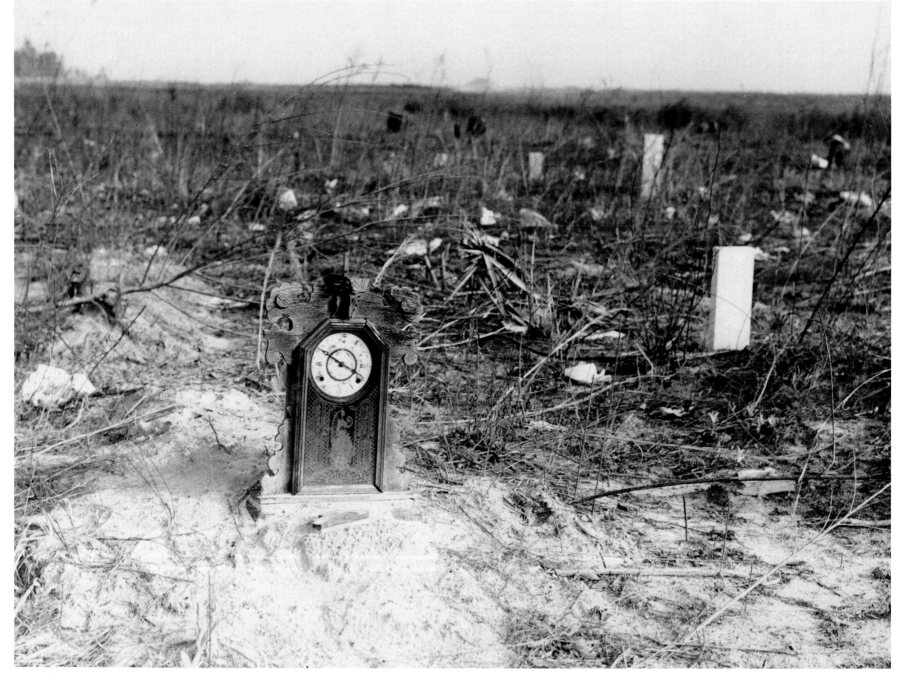

March 1941. Moncks Corner (vicinity).
A Negro graveyard on abandoned land in the
military reservation area.
JACK DELANO
LC-USF34 43572

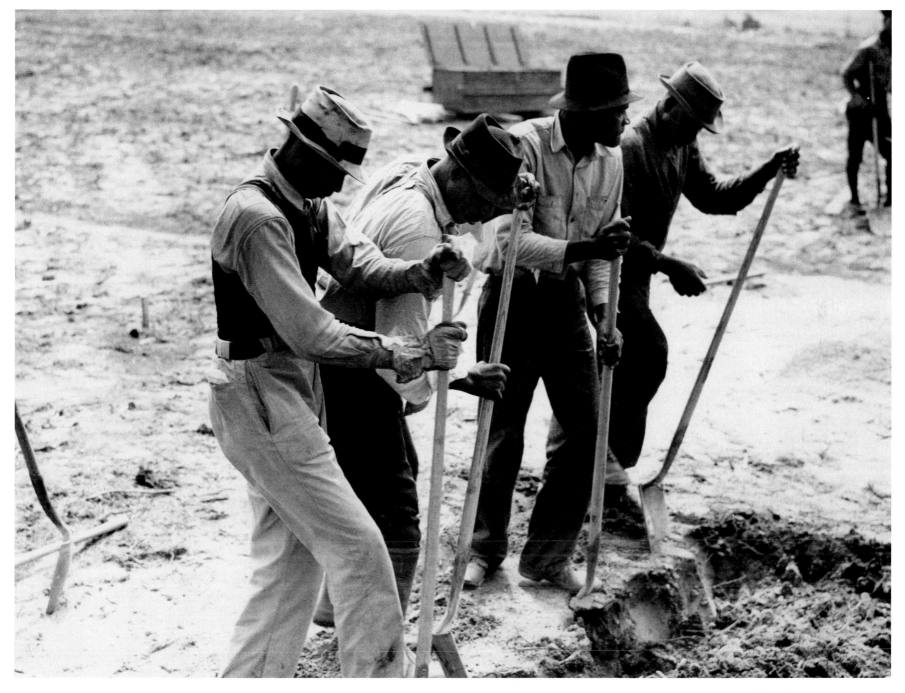

March 1941. Bonneau (vicinity).
Digging new graves for a cemetery which
is being moved out of the Santee-Cooper basin area.
JACK DELANO
LC-USF34 43506

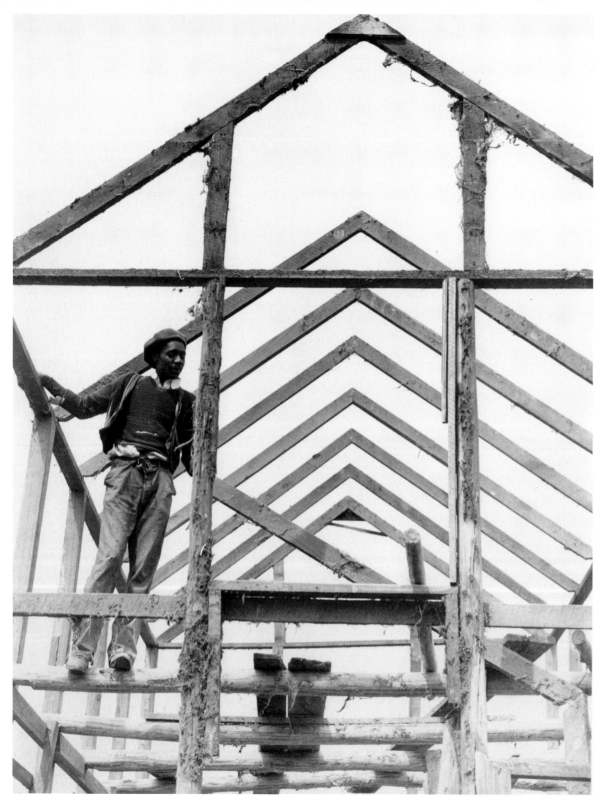

March 1941. Bonneau (vicinity).
Many families tore down their houses in the Santee-
Cooper basin to rebuild them outside the area.
JACK DELANO
LC-USF34 43456

March 1941. Bonneau (vicinity).
The interior of a one-room shack which is
in a settlement of Negro farmers who have
moved out of the Santee-Cooper basin area.
JACK DELANO
LC-USF34 43491

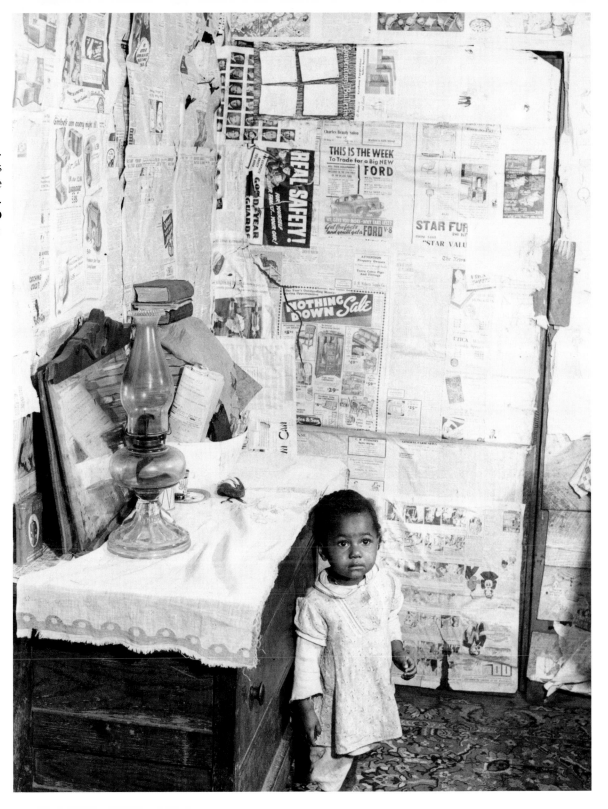

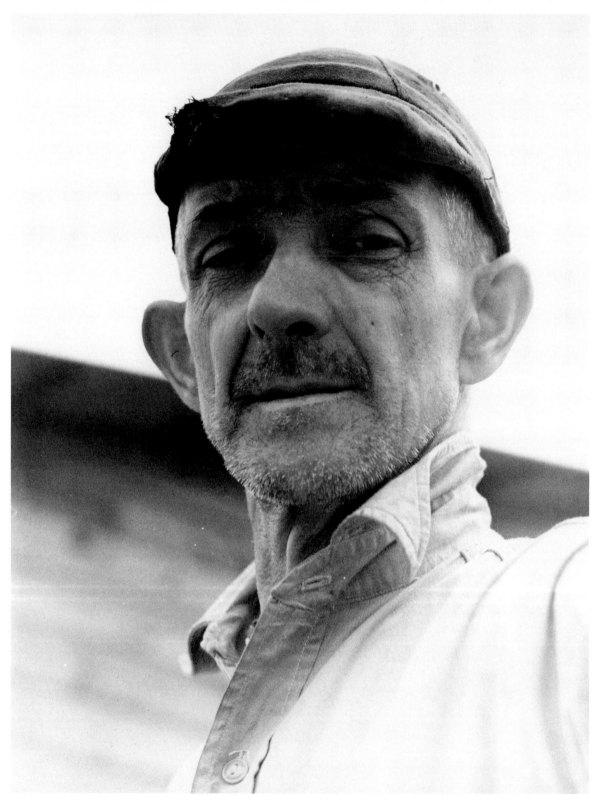

March 1941. Bonneau (vicinity).
A landowner who had to move out of the Santee-Cooper basin area.
JACK DELANO
LC-USF34 43524

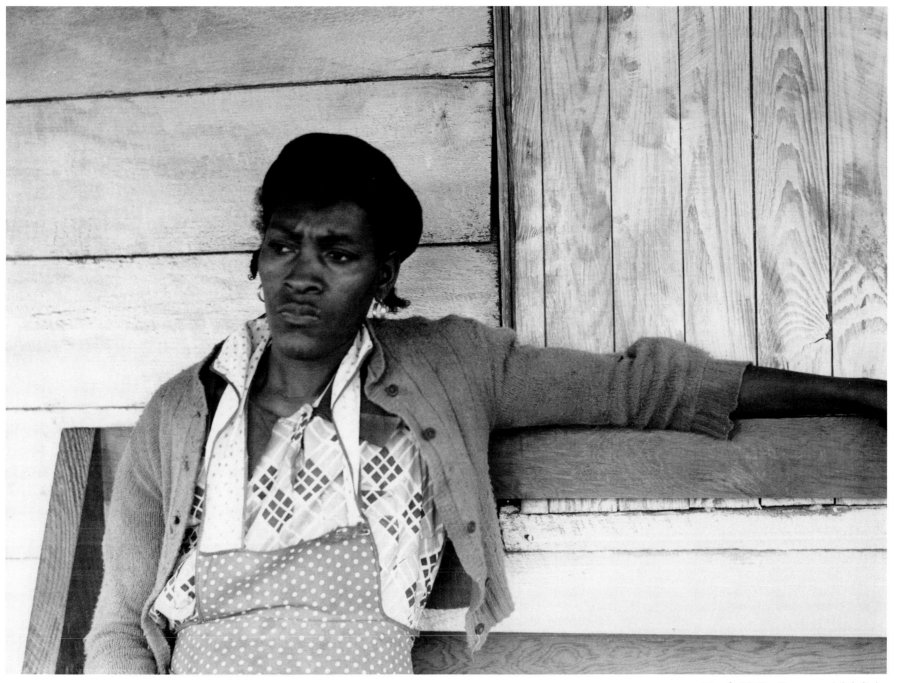

March 1941. Bonneau (vicinity).
A woman whose family moved from the
military reservation to uncleared farm land.
JACK DELANO
LC-USF34 43489

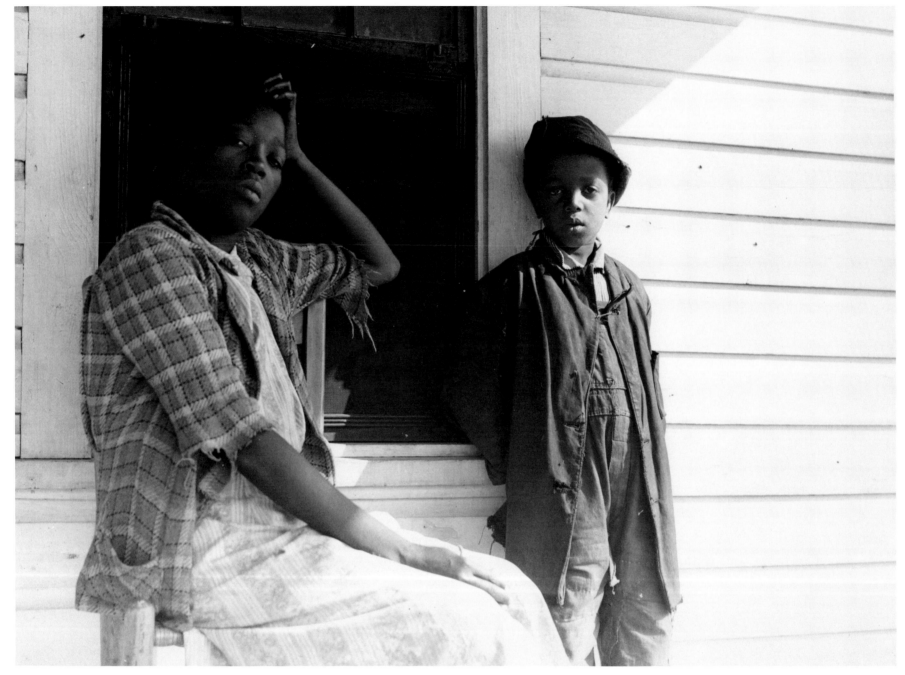

March 1941. Orangeburg.
A Negro boy and girl, members of a family who was relocated
at the Farm Security Administration Orangeburg farms when they
had to move out of the Santee-Cooper basin area.
JACK DELANO
LC-USF34 43580

Wartime Dislocation and Mobilization:
War Preparations on the Home Front, 1941-1943

More than anything else, the advent of World War II brought an increased mobility to South Carolina. The resettlement of the sharecroppers and tenants in Spartanburg did not promise new electrical power but the very different power to make war on a distant enemy. South Carolinians moved off their farms and homelands to make way for the building of Camp Croft, where within a short time thousands of young men were trained to be warriors. The war moved these young men from their homes just as it moved the tenants and sharecroppers from theirs. The photographs Jack Delano made during his two separate trips to South Carolina reflect all of these dislocations: families moving trunks and building new walls; the joys of a young South Carolina man coming home to his family; and the fellowship amd homesickness of young men far from their own families doing the job their country called on them to do.

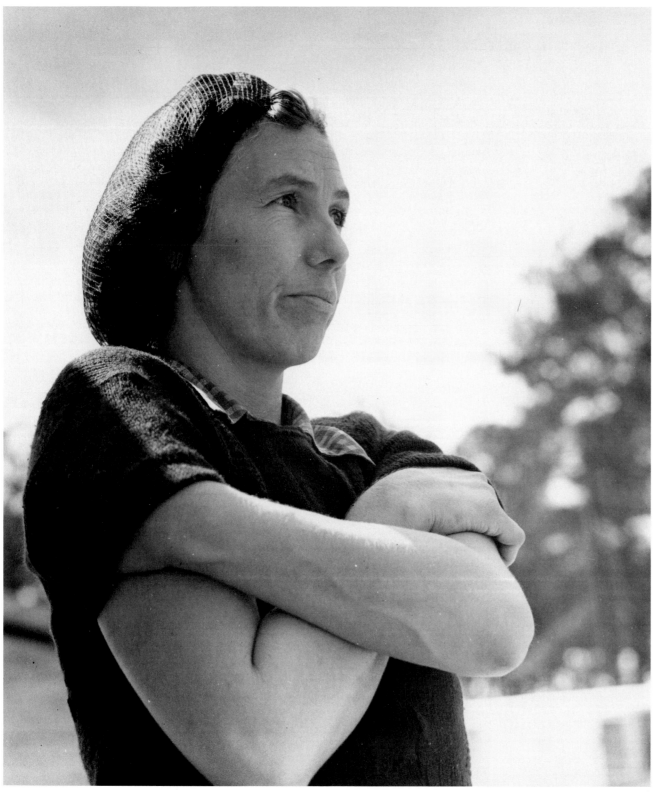

March 1941. Spartanburg (vicinity).
The wife of a construction worker
at Camp Croft. They live at a
trailer camp.
JACK DELANO
LC-USF34 43439

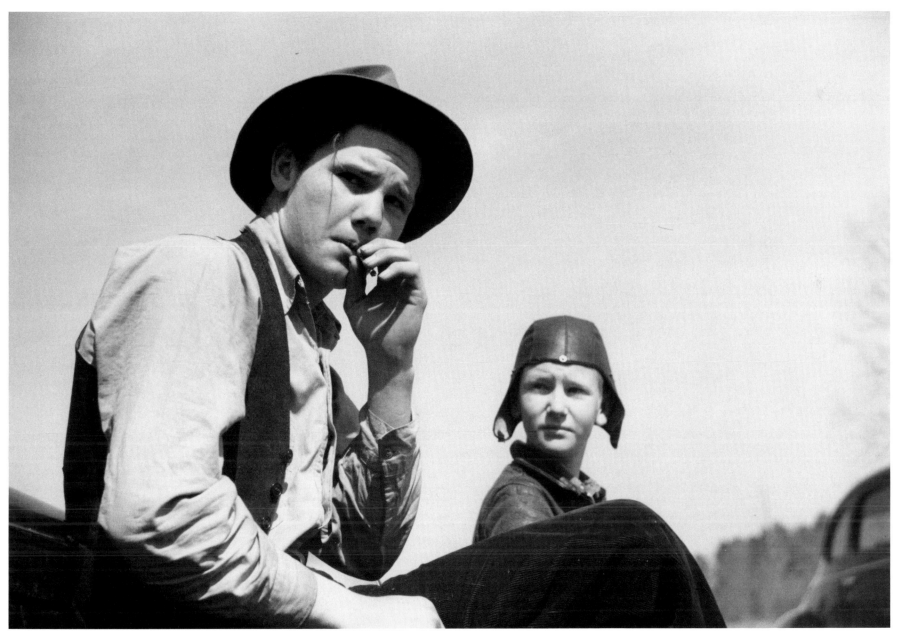

March 1941. Spartanburg.
Children of a family who are moving out of the
military reservation area.
JACK DELANO
LC-USF33 20808-M3

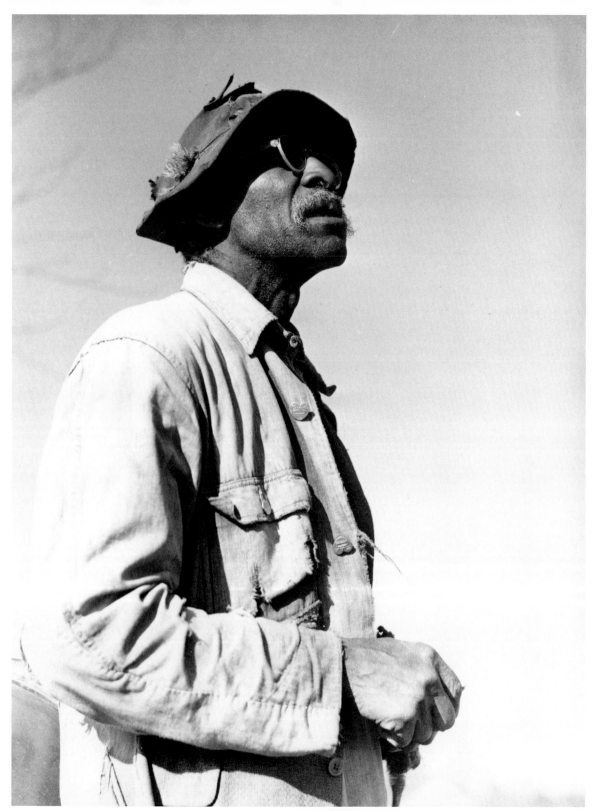

March 1941. White Stone (vicinity).
A. L. Anderson who owned a few acres of
land in the Camp Croft area. Although al-
most blind he was repairing an old house
in preparation to moving into it.
JACK DELANO
LC-USF34 43484

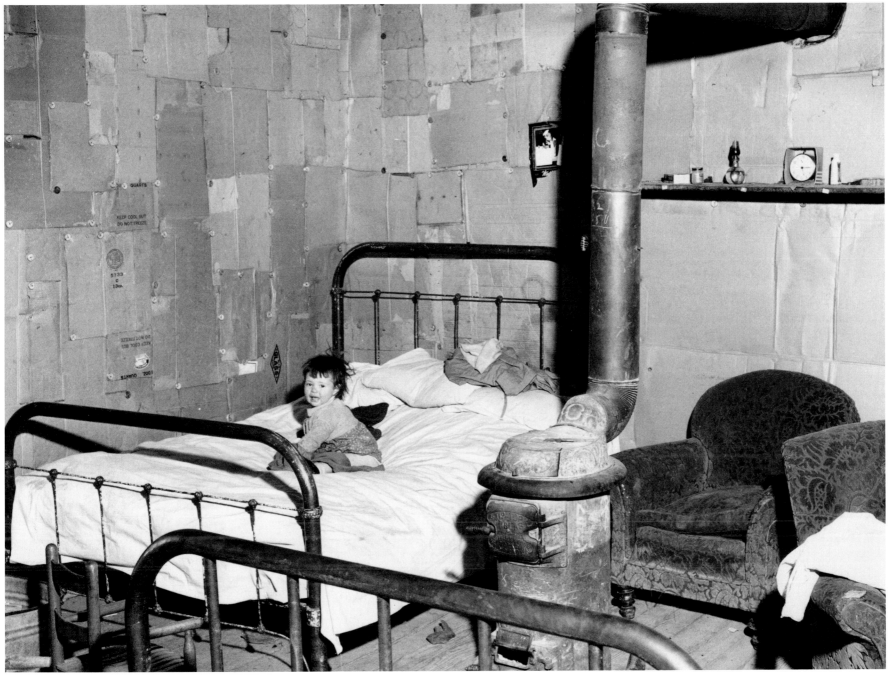

March 1941. White Stone (vicinity).
A combination bed and living room in the home
of a "squatter" family in the Camp Croft area.
JACK DELANO
LC-USF34 43520

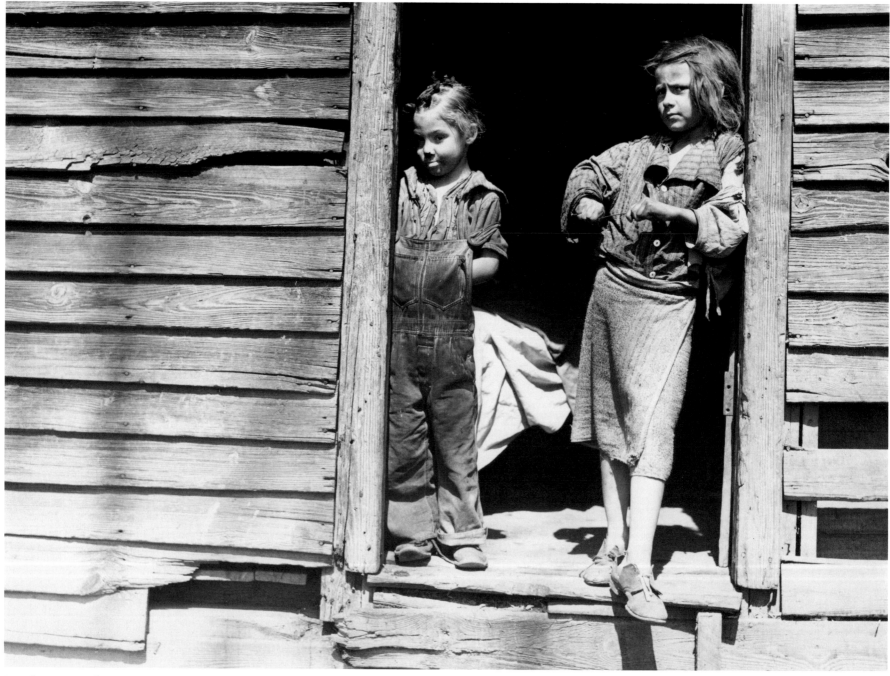

March 1941. White Stone (vicinity).
Two of the children of Willie Smith, a "squatter" who
had to move out of the Camp Croft area.
JACK DELANO
LC-USF34 43567

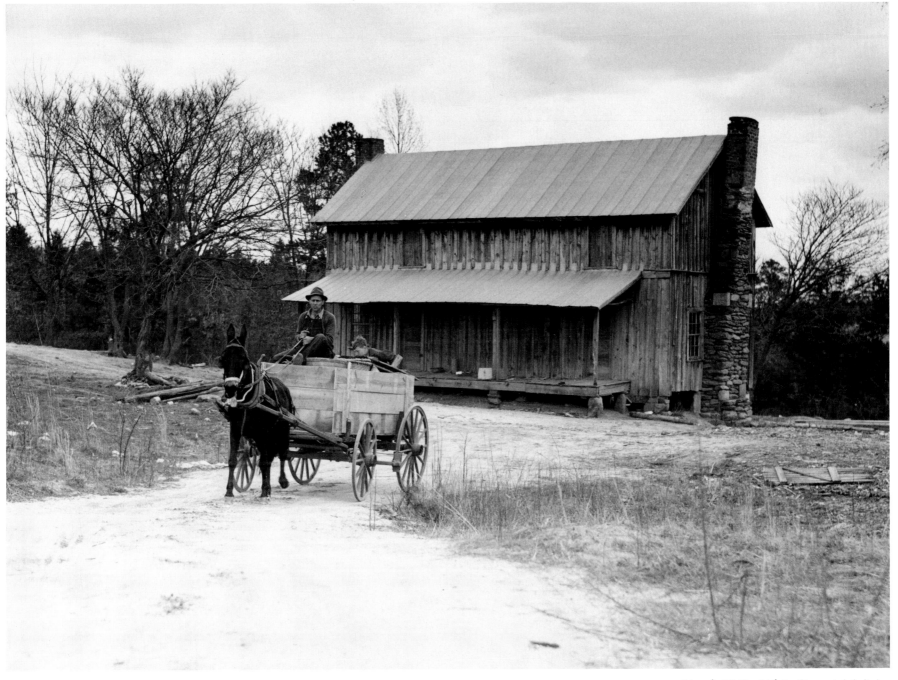

March 1941. White Stone (vicinity).
A tenant farmer moving the last of his belongings away from
his farm home, in the Camp Croft area.
JACK DELANO

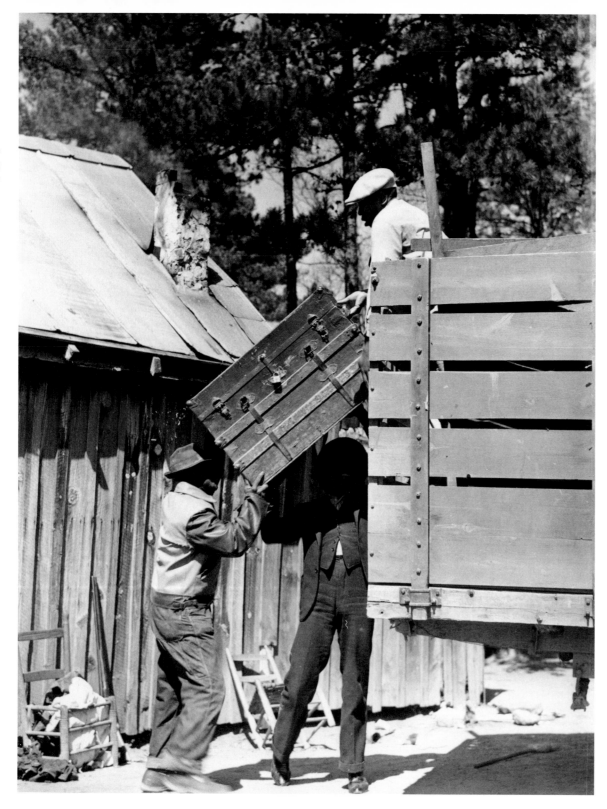

April 1941. Spartanburg (vicinity).
A family moving out of the military
reservation area.
JACK DELANO
LC-USF34 43661

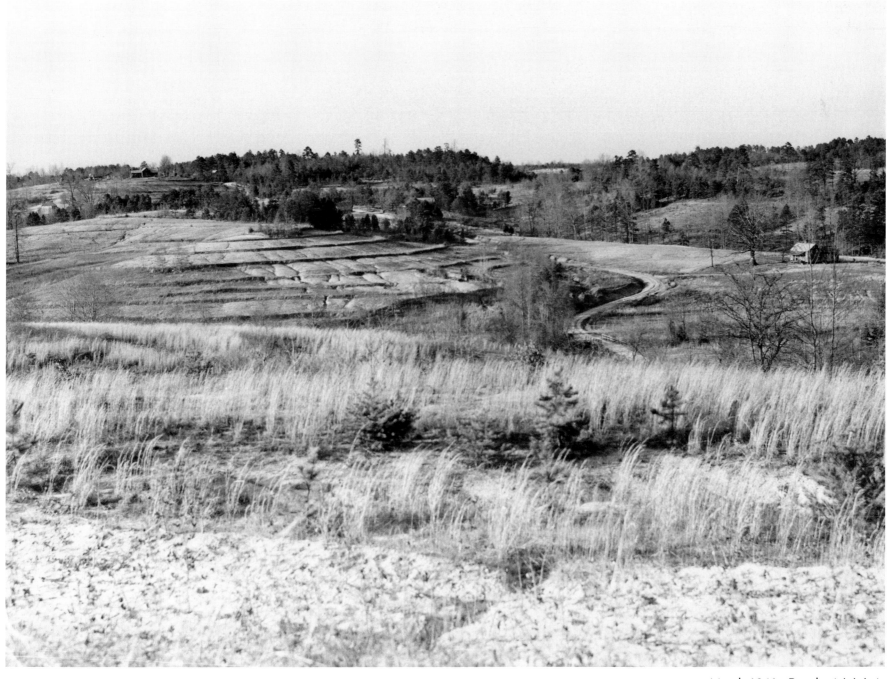

March 1941. Pacolet (vicinity).
Landscape in the Camp Croft area
showing eroded land.
JACK DELANO
LC-USF34 43641

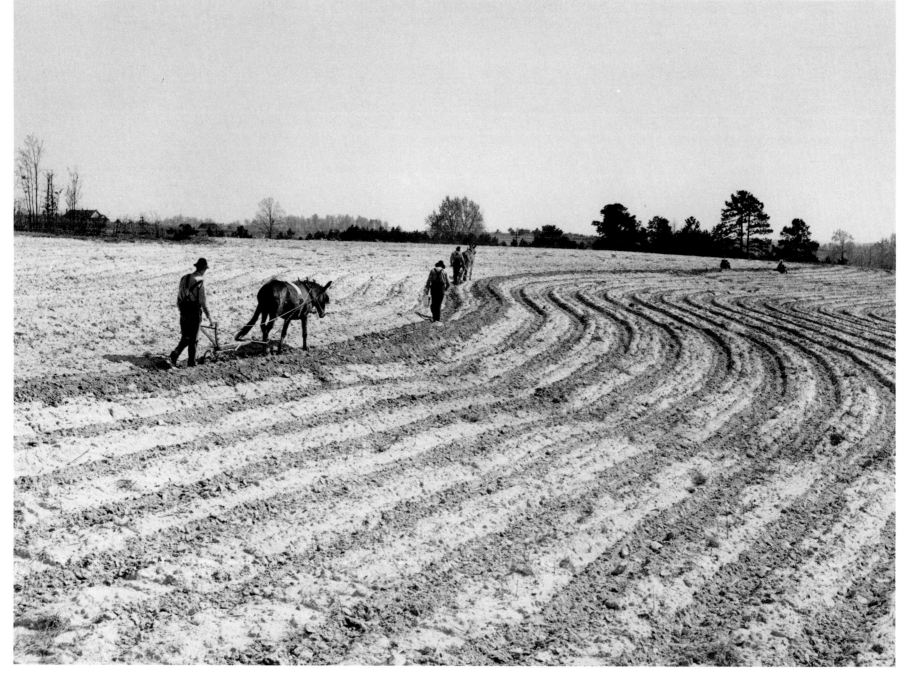

March 1941. Pacolet (vicinity).
Plowing and planting in a field.
JACK DELANO
LC-USF34 43815

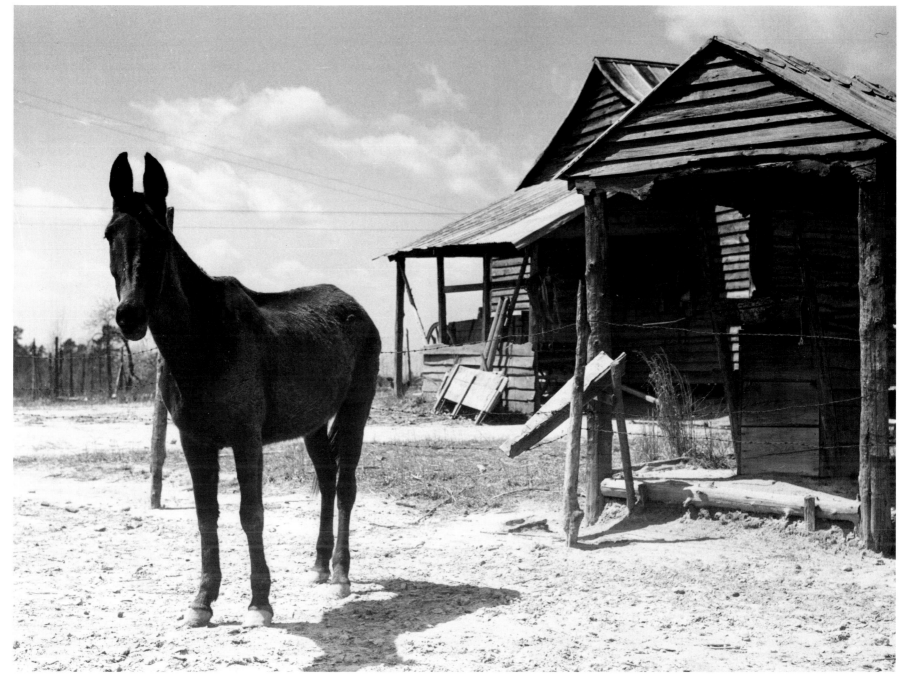

March 1941. Pacolet (vicinity).
A mule on a farm.
JACK DELANO
LC-USF34 43638

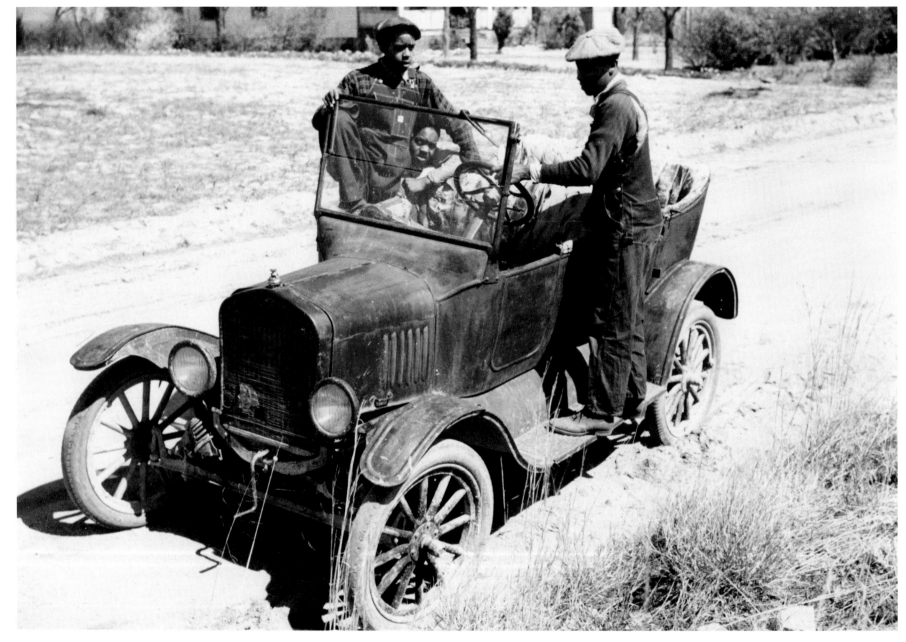

March 1941. Pacolet (vicinity).
Negro boys with a model "T" Ford car.
JACK DELANO
LC-USF33 20807-M1

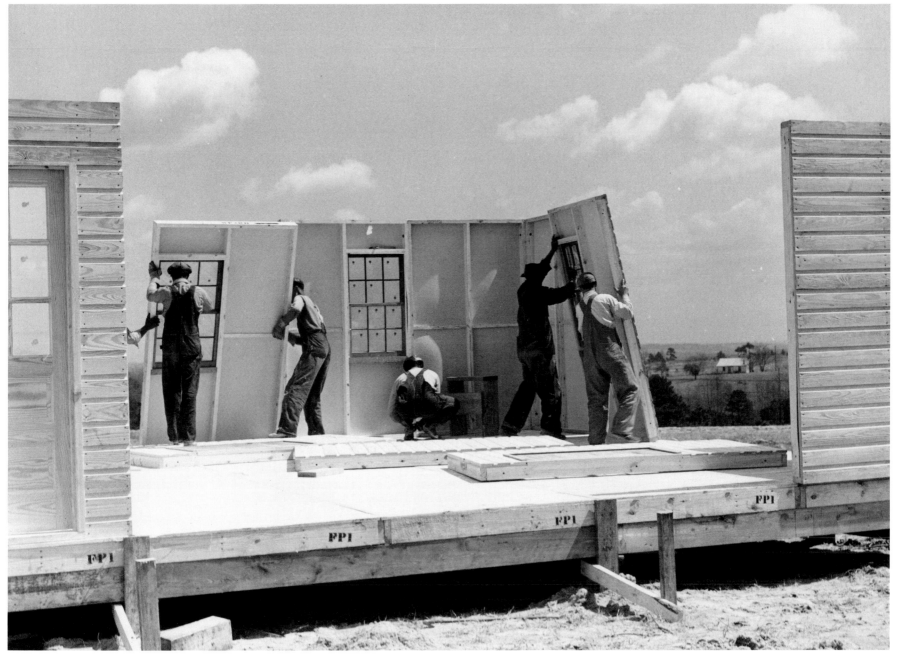

March 1941. Pacolet.
Putting up the walls of one of the houses which is being
built by the Farm Security Administration for families who
had to move out of the military reservation area.
JACK DELANO

March 1941. Pacolet.
A view through a window of one of
the pre-fabricated houses which the Farm
Security Administration is building for
families who were compelled to move
out of the military reservation area.
JACK DELANO
LC-USF34 43663

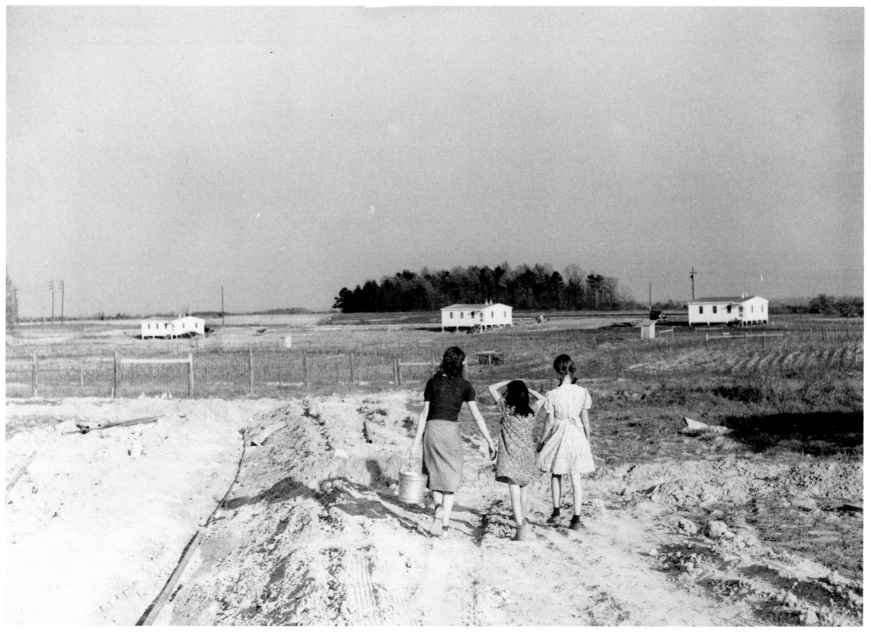

April 1941. Pacolet.
One of the householders carrying water for her home
while waiting for the water pipes to be laid. She lives in one of the pre-
fabricated houses built by the Farm Security Administration for families
who had to move out of the military reservation area.
JACK DELANO
LC-USF34 43817

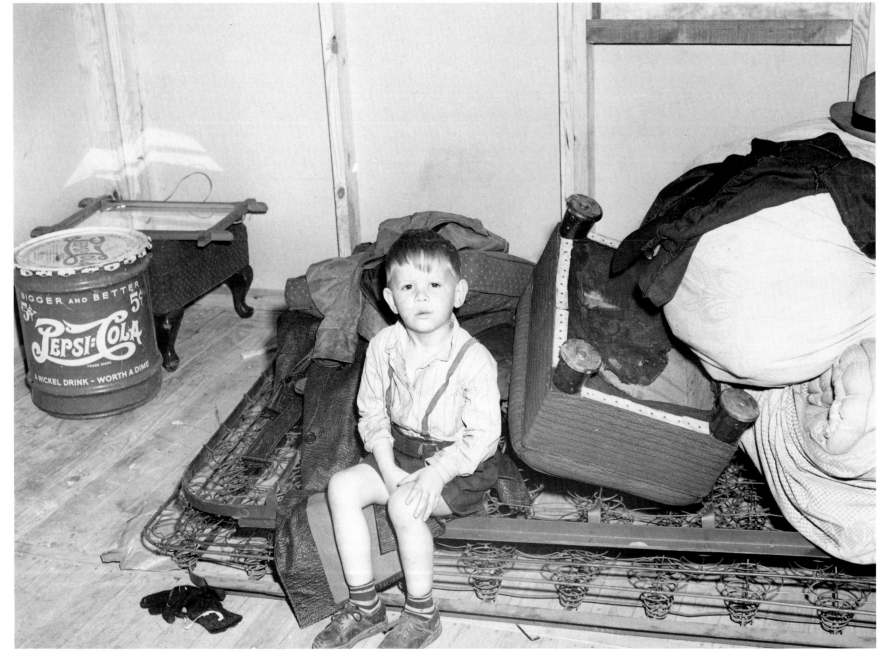

April 1941. Pacolet.
A little boy, a member of a family who has just moved into one of the pre-
fabricated houses built by the Farm Security Administration for families
compelled to move out of the military reservation area.
JACK DELANO
LC-USF34 43824

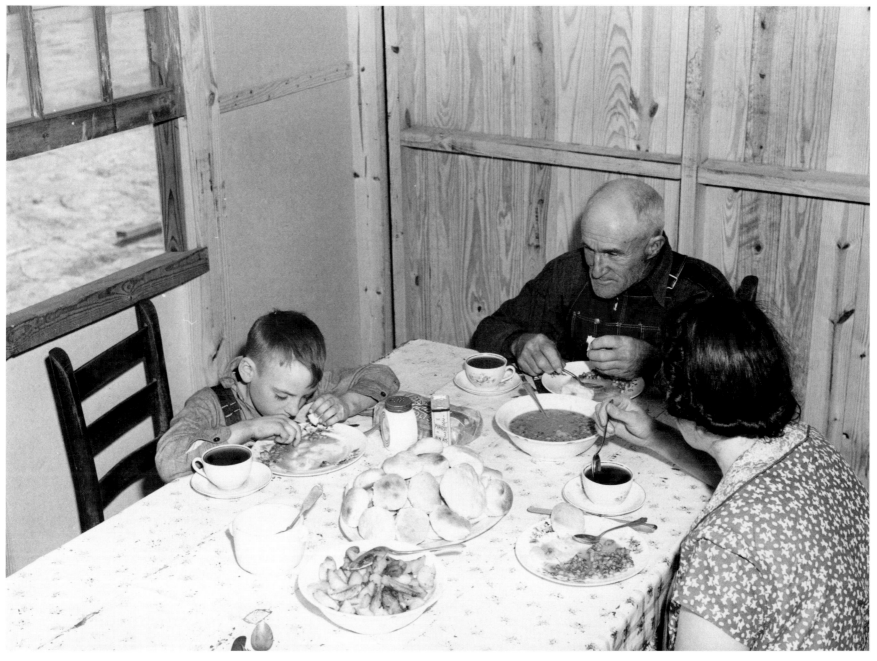

April 1941. Pacolet.
A family having lunch at their new home. They have moved into one
of the houses which the Farm Security Administration is building for families
who have had to move out of the military reservation area.
JACK DELANO
LC-USF34 43821

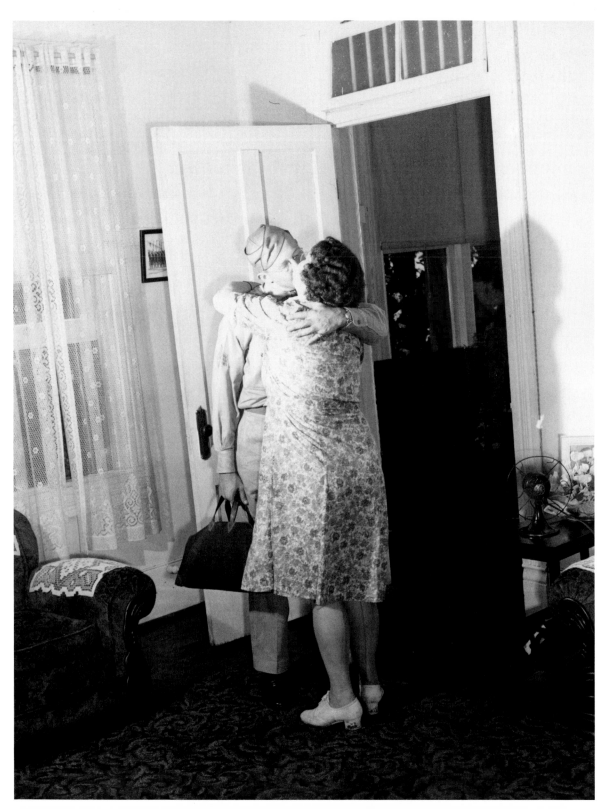

July 1943. Bowman.
Sgt. John Riley of the 25th service group, Air service command, coming home on leave.
JACK DELANO
LC-USW3 35529

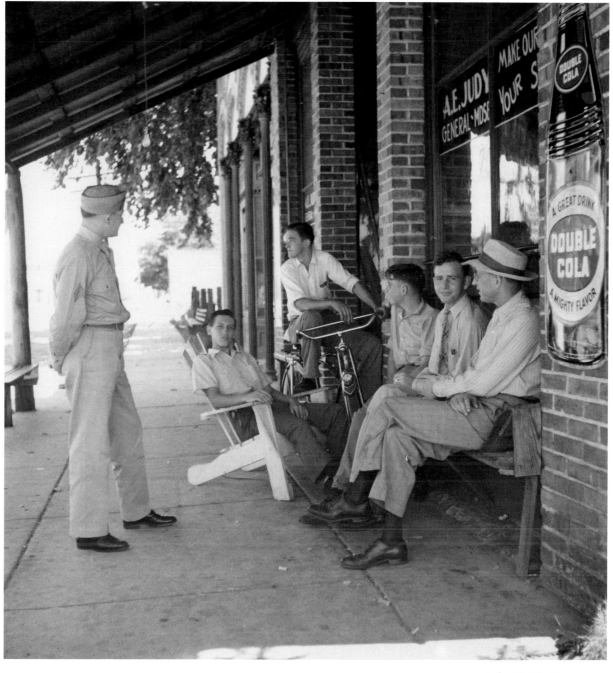

July 1943. Bowman.
Sgt. John Riley of the 25th service group, Air service command,
talking with friends while on leave at his home. Before enlisting in the army,
Sgt. Riley worked in his father's garage for many years.
JACK DELANO
LC-USW3 35468

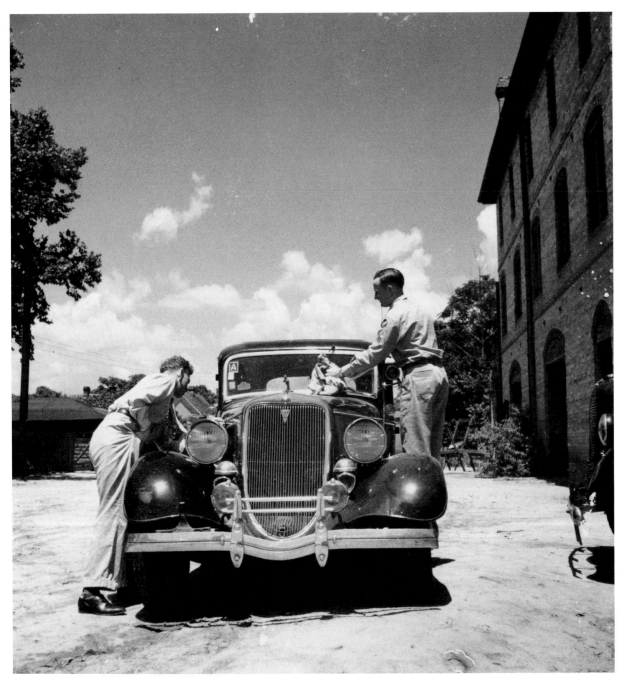

July 1943. Bowman.
Sgt. John Riley of the 25th
service group, Air service command,
on leave at his home. With the help
of a friend, he is cleaning his little
Ford, preparing to go see his girl
friend in Charleston, S.C.
JACK DELANO
LC-USW3 35460

July 1943. Greenville.
Air service command. Aerial view showing a complete service
group with most of its equipment.
JACK DELANO
LC-USW3 35517

July 1943. Greenville.
Air service command. Enlisted
man shaving, in the wooded
area occupied by the 25th
service group.
JACK DELANO
LC-USW3 35705

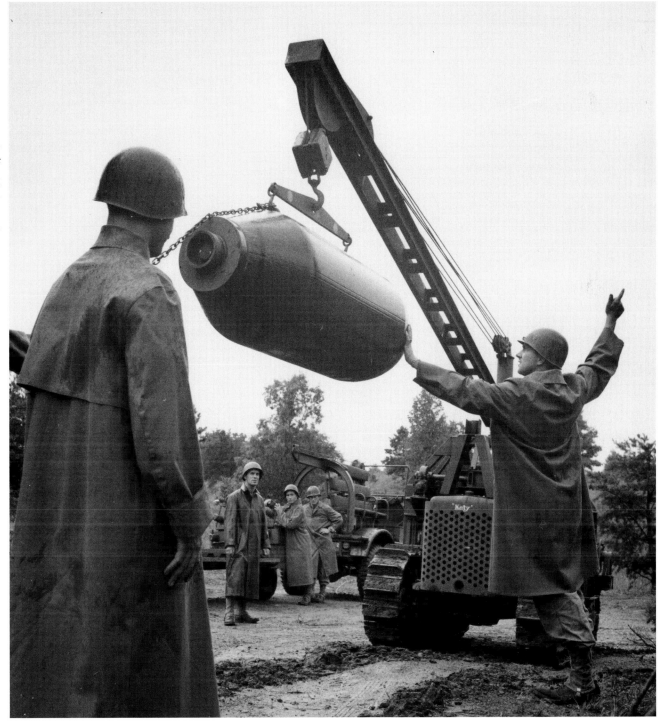

July 1943. Greenville.
Air service command.
Men of the ordnance, supply
and maintenance company of
the 25th service group, taking
2,000 lb. bombs out of the
revetment area.
JACK DELANO
LC-USW3 35425

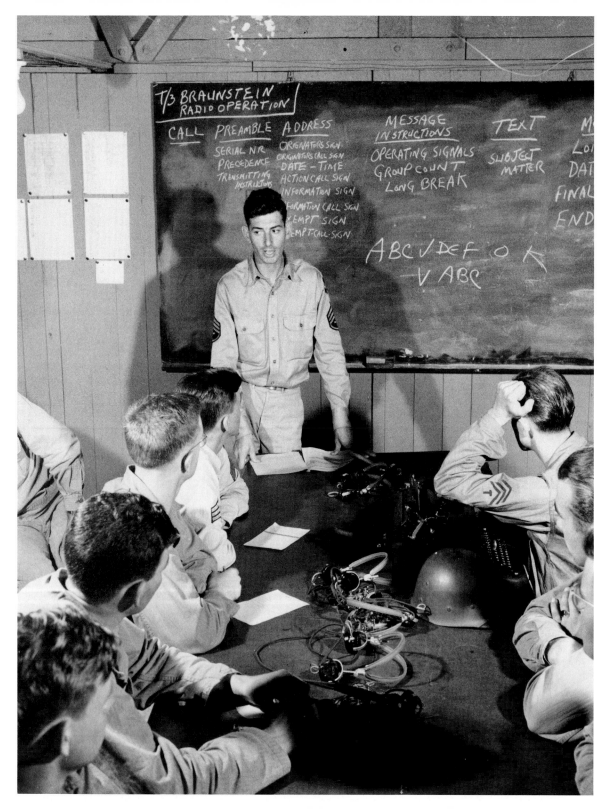

July 1943. Greenville.
Air service command. Men of the 1067th signal company of the 25th service group, attending a class in the procedure for sending messages.
JACK DELANO
LC-USW3 35515

July 1943. Greenville. Air service command. Hanging a parachute up to dry at the 35th service squadron of the 25th service group.
JACK DELANO
LC-USW3 35511

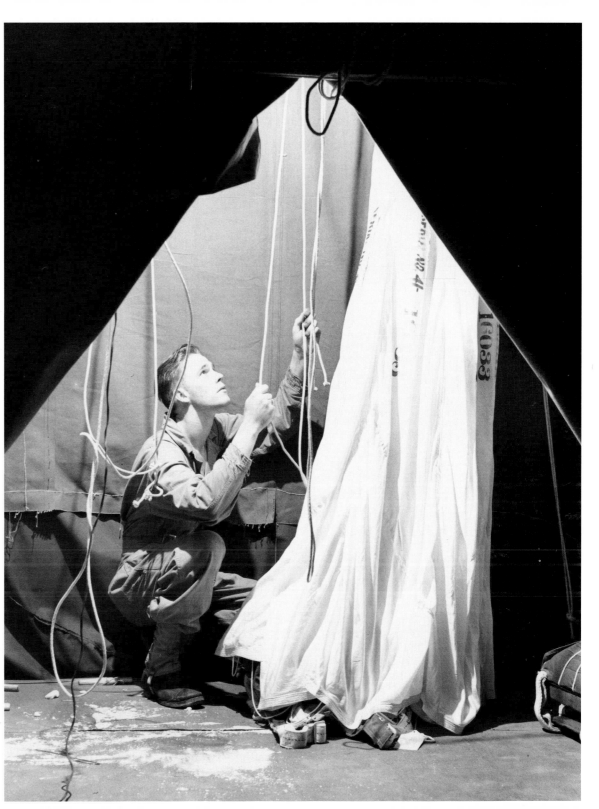

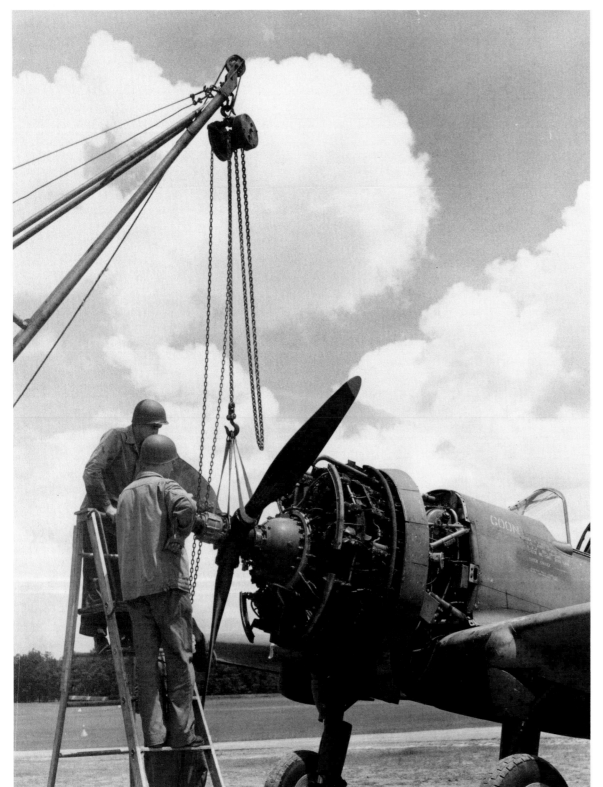

July 1943. Greenville.
Air Service command. Men of the 25th
service squadron of the the 25th service
group removing the propeller
of a plane.
JACK DELANO
LC-USW3 35539

July 1943. Greenville.
Air service command. Reading
a letter from home.
JACK DELANO
LC-USW3 35440

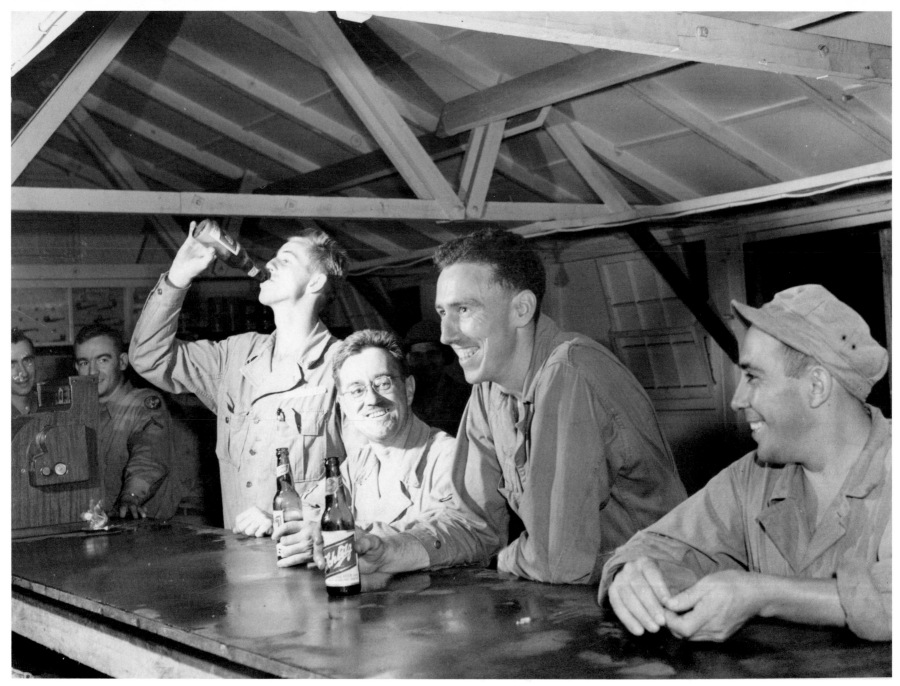

July 1943. Greenville.
Air service command. Group of service men
having beer in the post exchange.
JACK DELANO
LC-USW3 35557

July 1943. Greenville. Air service command. Enlisted men of the 25th service group playing with a puppy.
JACK DELANO
LC-USW3 35409

July 1943. Columbia.
Air service command. Testing gas
masks at a chemical unit of an air service
group.
JACK DELANO
LC-USW3 35645

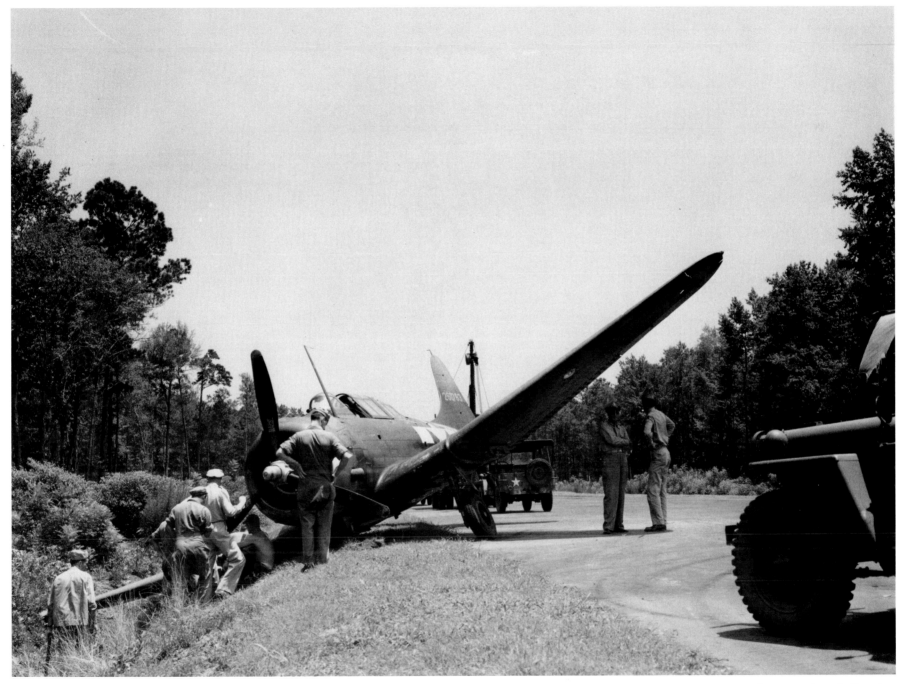

July 1943. Myrtle Beach.
Air service command. A mobile
unit working on an A-20 which
ran off a taxi strip.
JACK DELANO
LC-USW3 35640

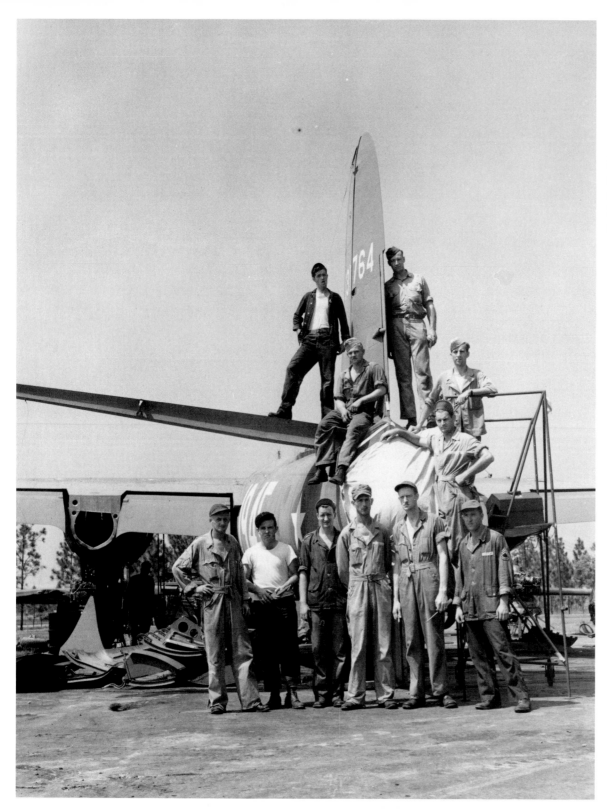

July 1943. Myrtle Beach.
Air service command. The men of
a mobile unit of the 25th service group.
JACK DELANO
LC-USW3 35625

Change and Continuity:
Postwar Readjustment and Prosperity, 1947-1948

The end of the war brought South Carolina peace and prosperity; peace brought a return to old values and an economic boost into the twentieth century. Modern school buses transported children to substantial brick school buildings. A new industry built on the renewable resource of the pine that grew so readily in South Carolina's soil brought both new jobs and the chemicals and industrial smoke that a later generation would criticize as unhealthful. For the children in Beaufort, Christmas of 1948 promised a new world of consumer goods and a bright future. Yet the rolling furrows of a freshly plowed field still meant a hard day of work and the hope of a good crop and a good price for many of South Carolina's families. The church, the family, the community remained the solid bedrock from which the state and its people faced the mid-twentieth century.

November 1947. International Paper
Company, Georgetown.
Company forester measuring tree with
a tree caliper in a ten-year-old planting.
ARNOLD EAGLE
University of Louisville Neg. 53607

November 1947.
International Paper
Company, Woodland
operation, Georgetown.
L. E. Howard, district
forester, with a fire tank
truck which is equipped
with a two-way radio.
ARNOLD EAGLE
University of Louisville Neg.
53673

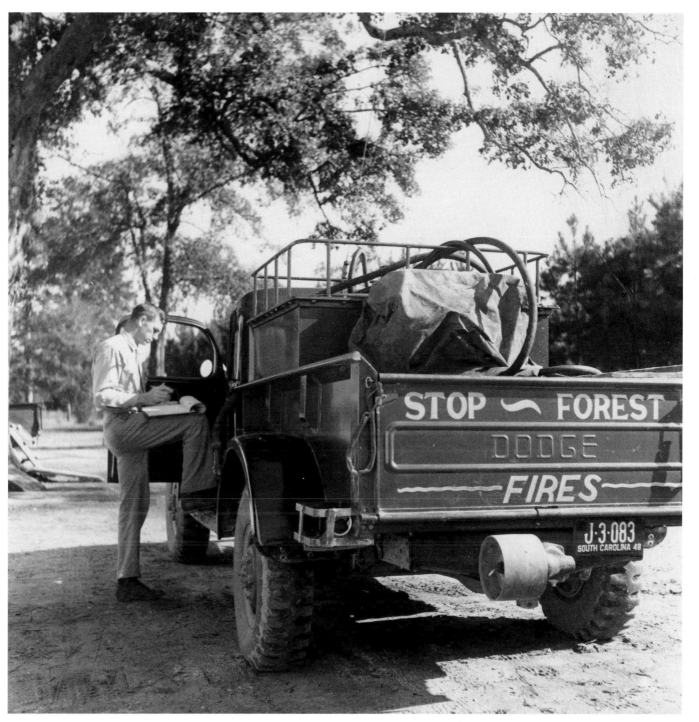

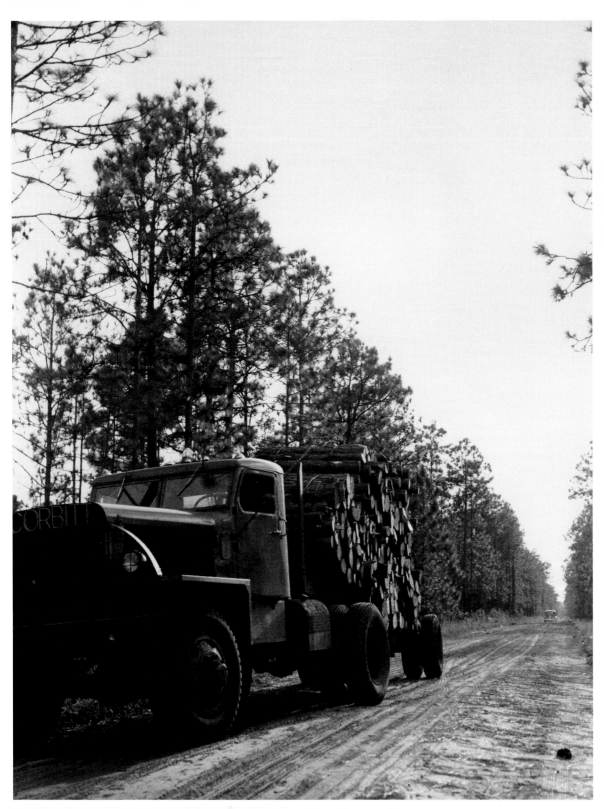

November 1947. International Paper
Company, Paper Mill, Georgetown.
Corbitt tractor and trailer taking pulpwood
to the mill.
ARNOLD EAGLE
University of Louisville Neg. 53630

November 1947.
International Paper
Company, Paper Mill,
Georgetown.
A derrick
moves the pulpwood from
the woodpulp pile to the
conveyor which takes it from
the yard to the mill. It takes
2,400 cords of pulpwood a
day to keep the mill going.
ARNOLD EAGLE

University of Louisville Neg. 53615

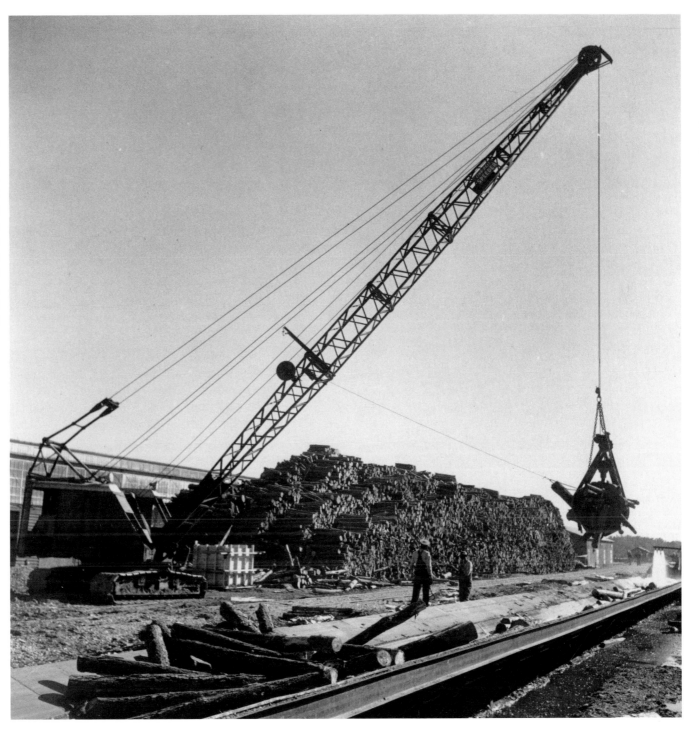

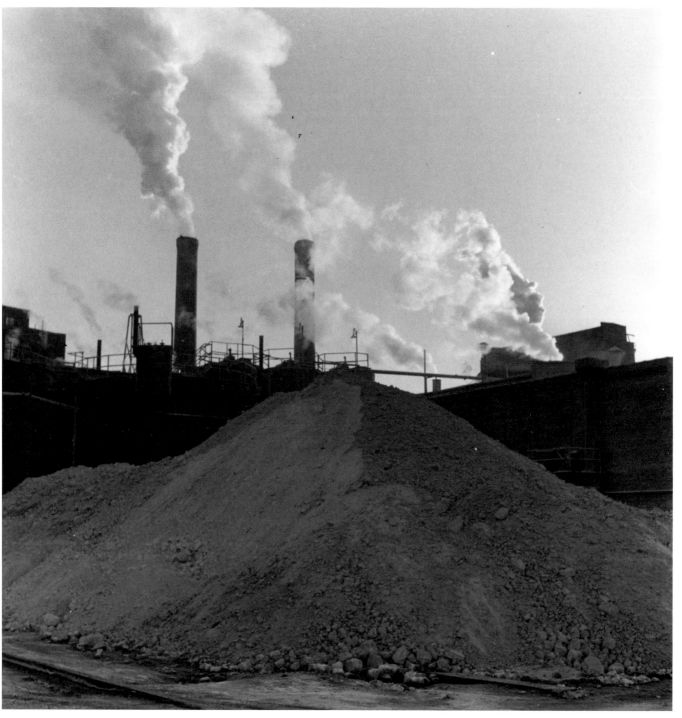

118

November 1947.
International Paper Company, Paper Mill,
Georgetown.
Sulphite used in
paper production.
ARNOLD EAGLE
University of Louisville Neg. 53619

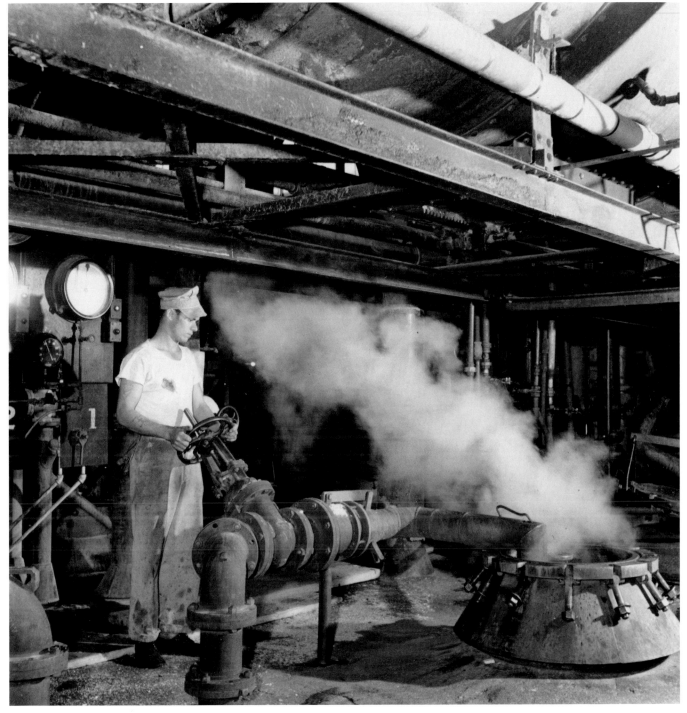

November 1947.
International Paper
Company, Paper Mill,
Georgetown.
Cooking liquor is pumped into
the digester which is filled with
wood chips.
ARNOLD EAGLE

University of Louisville Neg. 53622

119

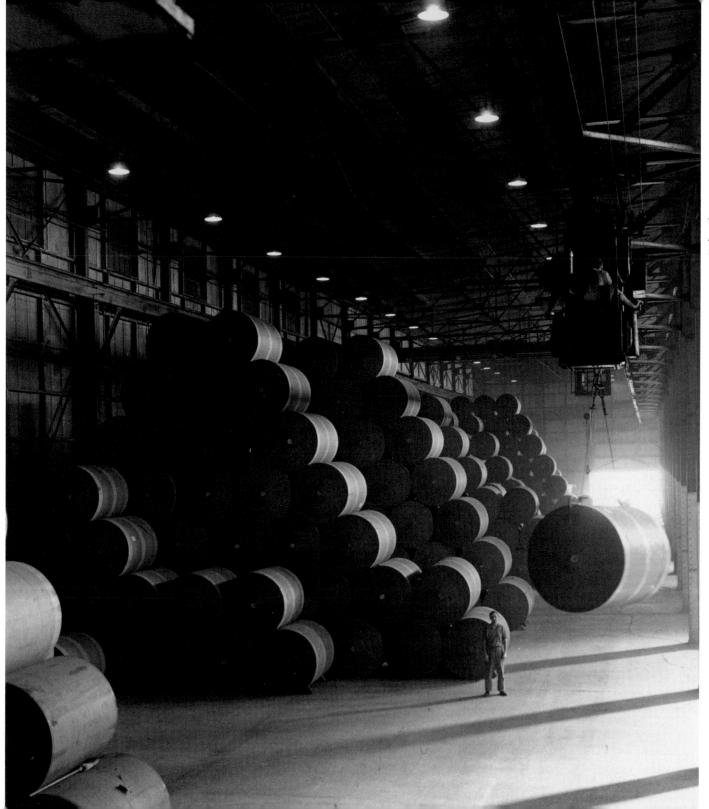

November 1947.
International Paper Company,
Paper Mill, Georgetown.
Rolls of paper stored in the
warehouse before shipment.
ARNOLD EAGLE
University of Louisville Neg. 53627

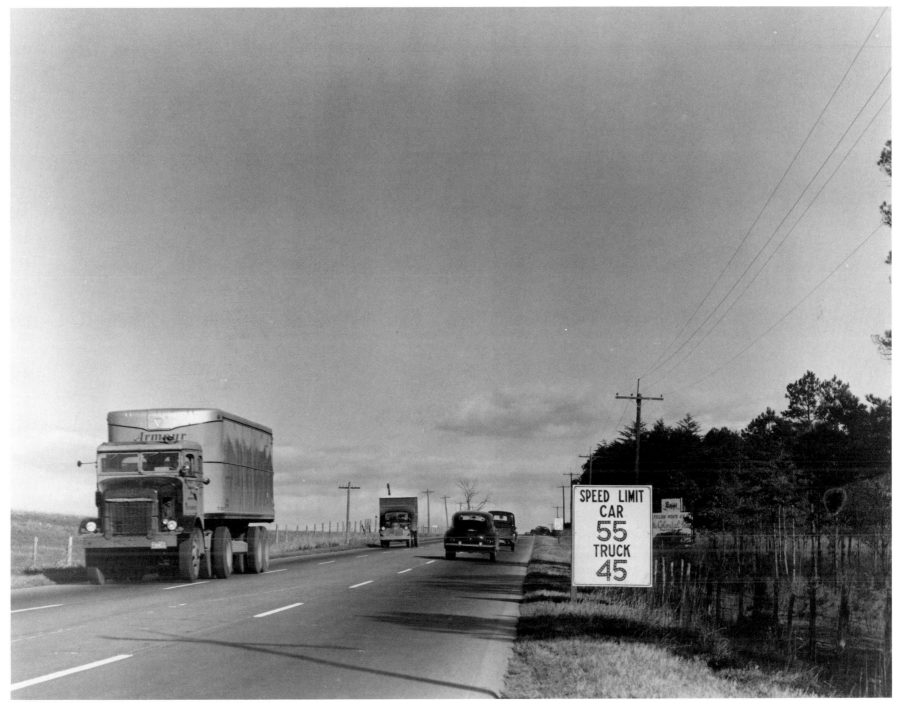

November 1948.
Highway #1 in South Carolina near the Georgia state line.
TODD WEBB
University of Louisville Neg. 62423

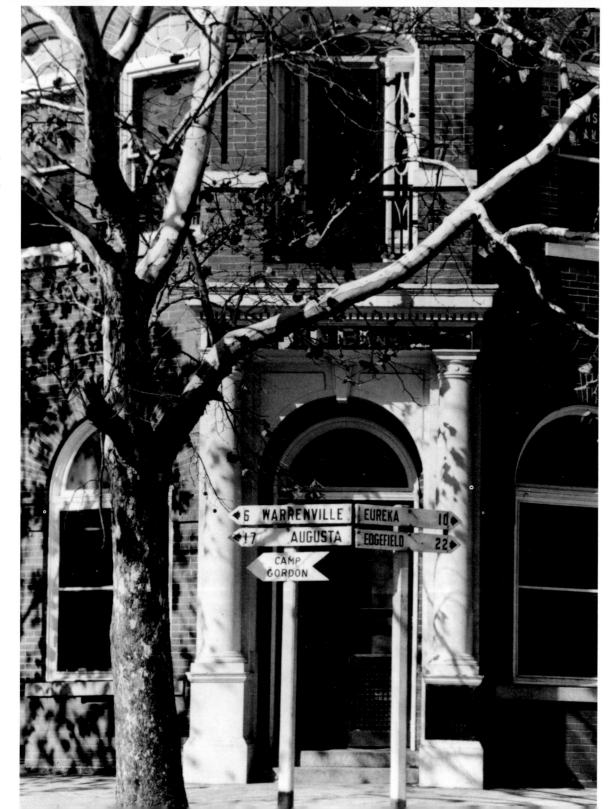

122

November 1948.
Street corner in Aiken.
TODD WEBB
University of Louisville Neg. 62419

November 1948. Sand Hill Country.
"Doc" Mitchell's Drug Store, Edgefield.
MARTHA ROBERTS
University of Louisville Neg. 63162

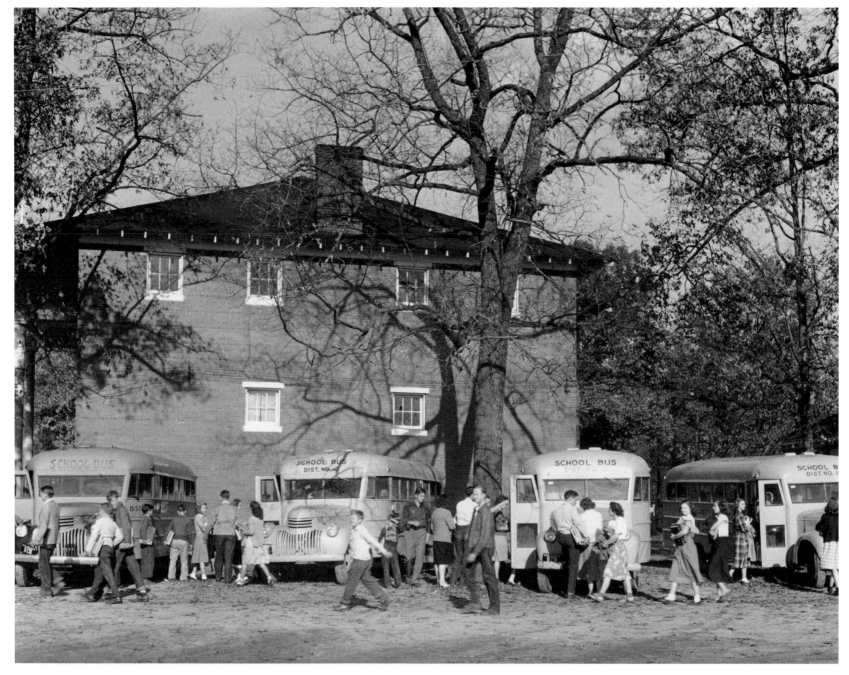

November 1948. The Carolina Sandhill Country in the vicinity of Aiken.
Busses loading after school. Edgefield County School near Edgefield.
MARTHA ROBERTS

University of Louisville Neg. 63952

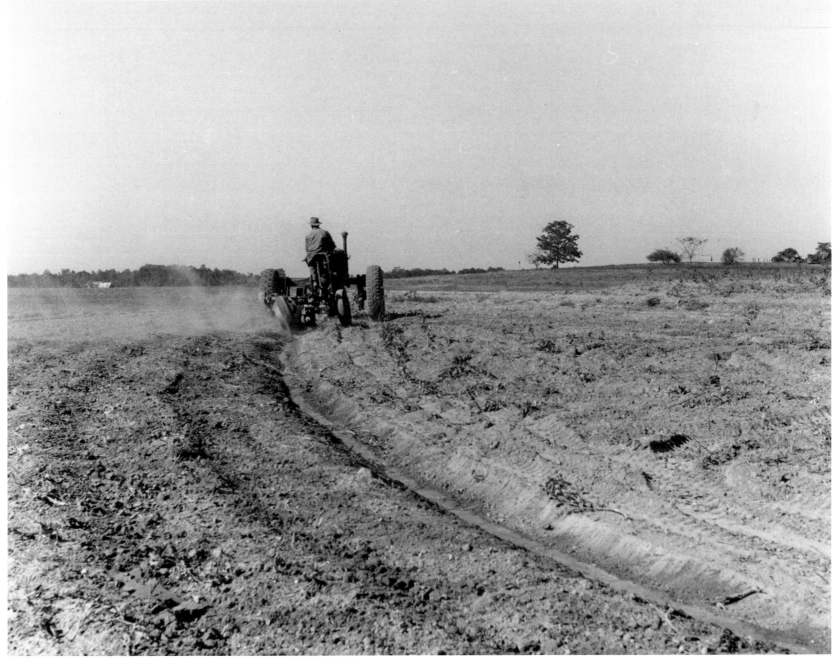

November 1948. Sand Hill Country.
Building terraces and preparing the land with a disc tiller for the
planting of oats on the farm of J.G. Awford near Edgefield.
MARTHA ROBERTS
University of Louisville Neg. 63171

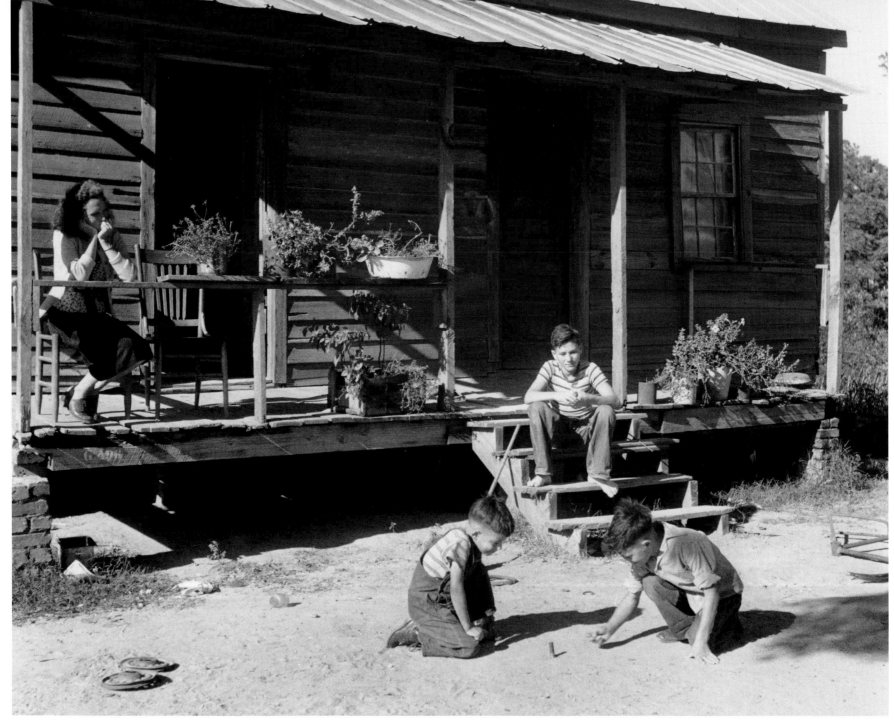

November 1948. Sand Hill Country.
A chalk mine worker's family near Langley.
MARTHA ROBERTS
University of Louisville Neg. 63156

November 1948.
Sand Hill Country.
Candied apples and
cotton candy.
State Fair, Columbia.
MARTHA ROBERTS
University of Louisville Neg. 63178

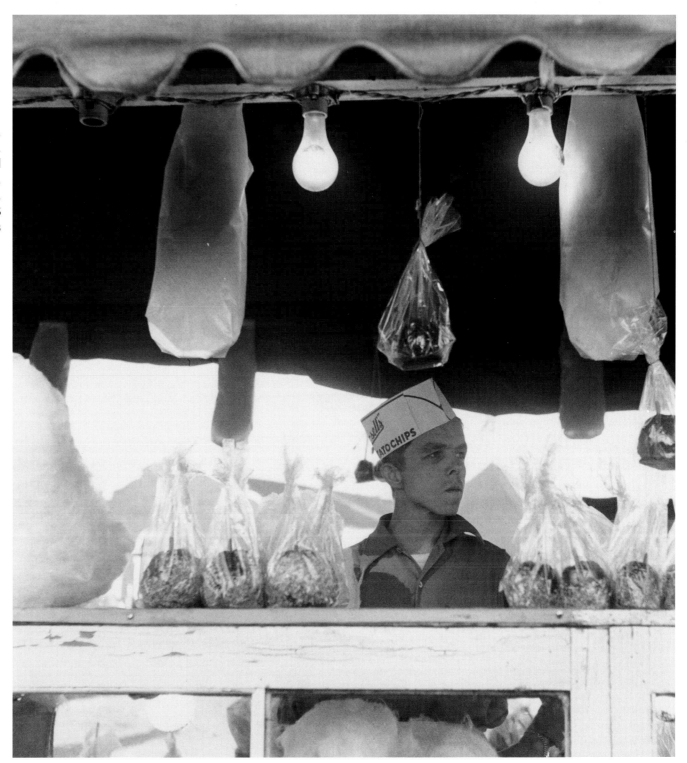

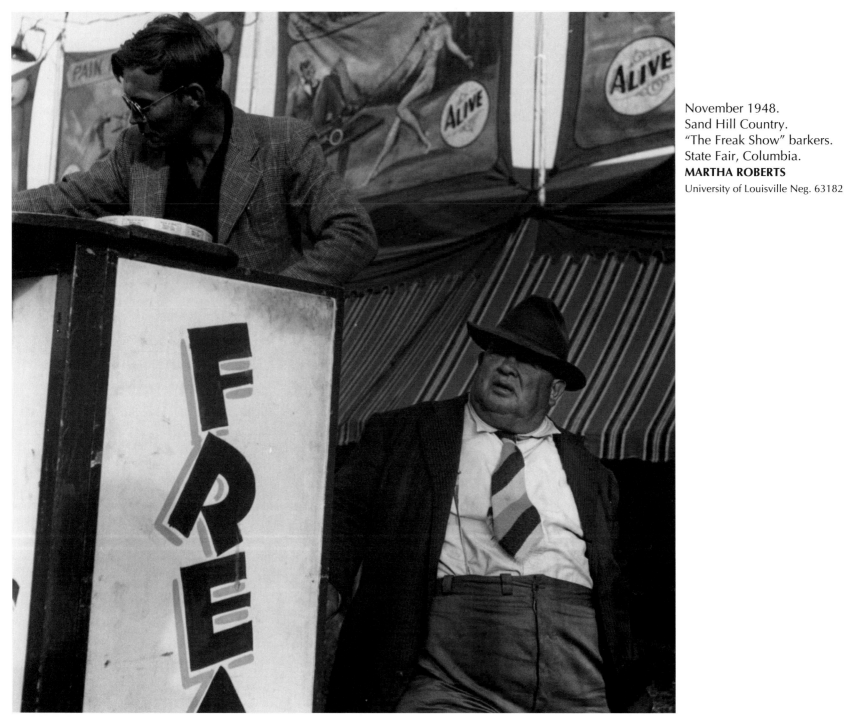

November 1948.
Sand Hill Country.
"The Freak Show" barkers.
State Fair, Columbia.
MARTHA ROBERTS
University of Louisville Neg. 63182

December 1948.
The Carolina Sandhill
Country in the
vicinity of Aiken.
Farmer Jack Wade.
Quebie Town.
MARTHA ROBERTS
University of Louisville Neg. 63940

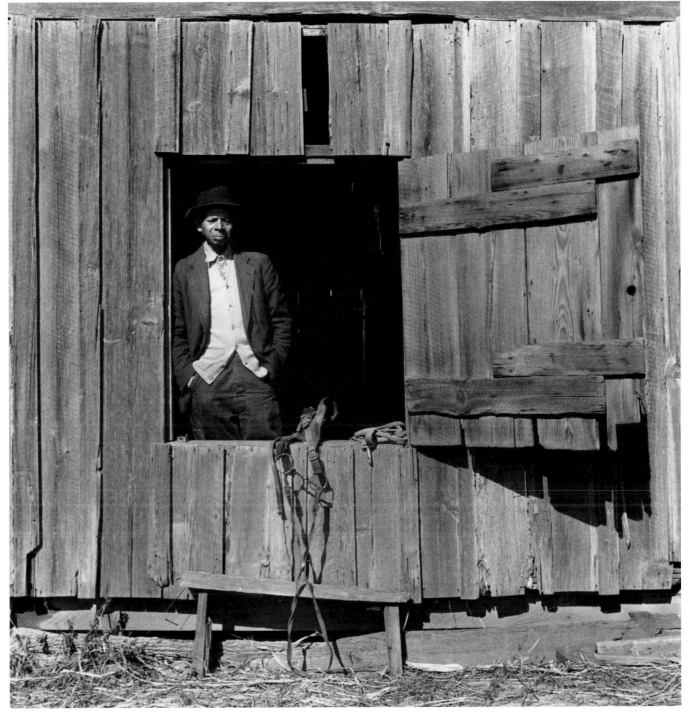

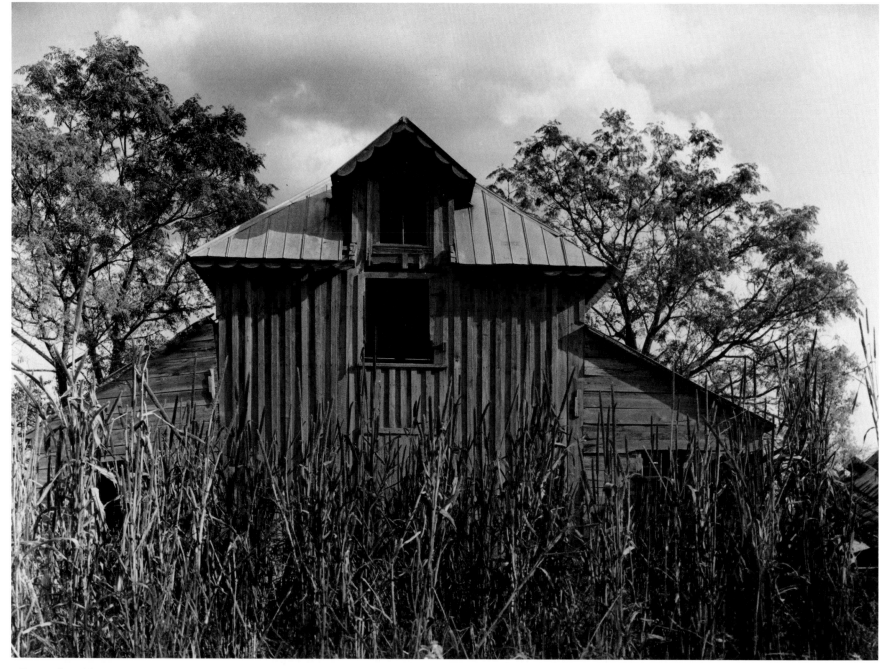

December 1948.
The Carolina Sandhill Country in the vicinity of Aiken.
Horse millet and barn. Harry Weatherford's farm near Beach Island.
MARTHA ROBERTS
University of Louisville Neg. 63965

December 1948. The
Carolina Sandhill Country
in the vicinity of Aiken.
Rose Harrison, 89-year-old
cotton picker. Beach Island.
MARTHA ROBERTS
University of Louisville Neg. 63955

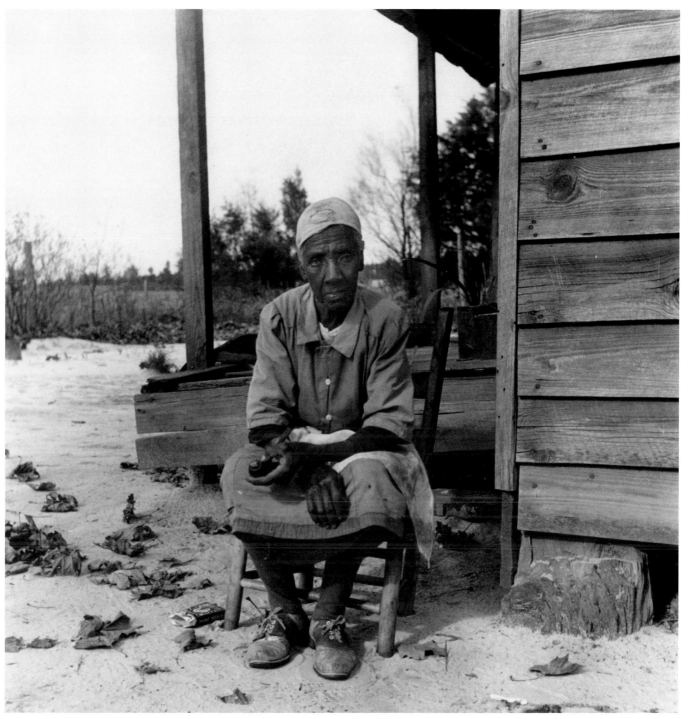

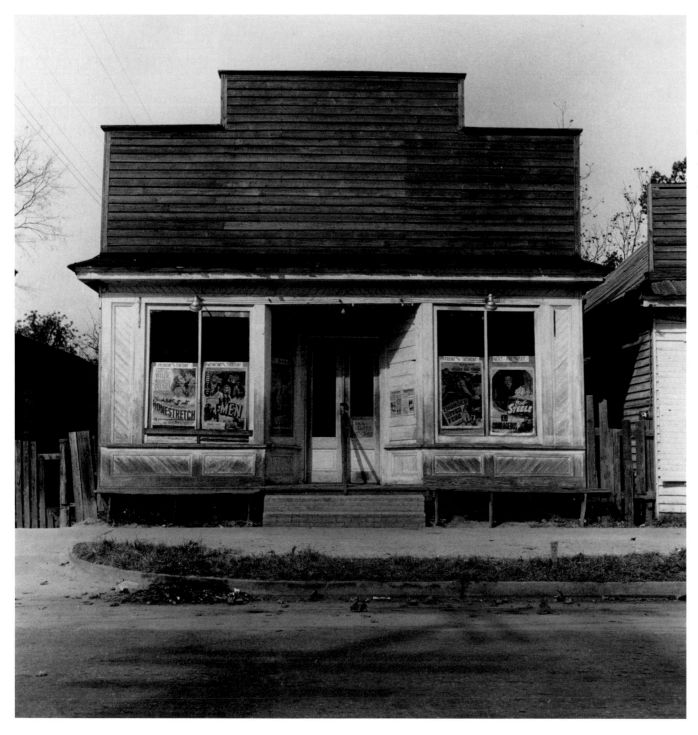

December 1948.
The Carolina Sandhill Country
in the vicinity of Aiken.
Theatre, Ellenton.
MARTHA ROBERTS
University of Louisville Neg. 63950

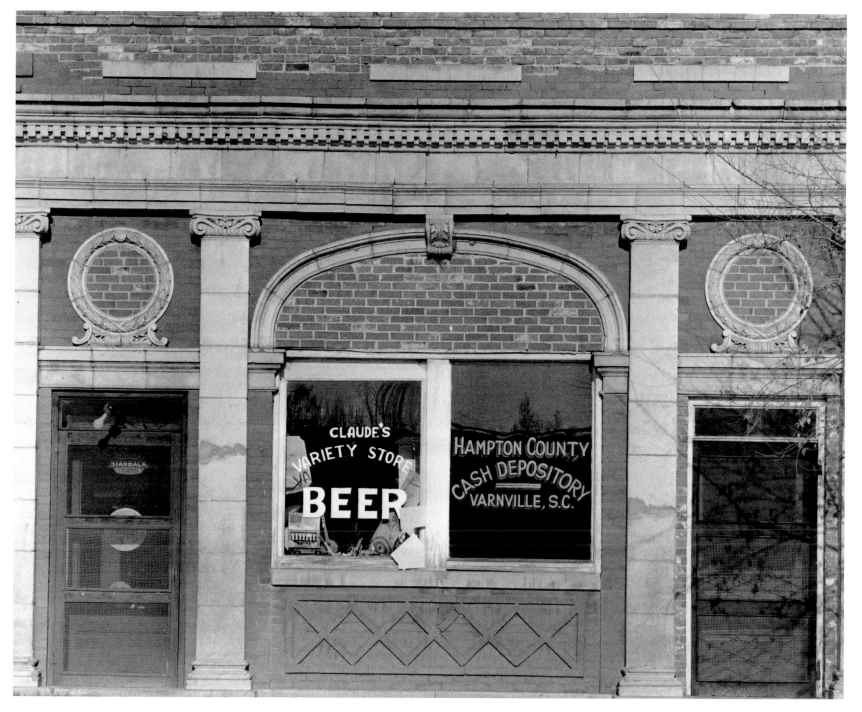

December 1948. Varnville.
Store and bank.
MARTHA ROBERTS
University of Louisville Neg. 63518

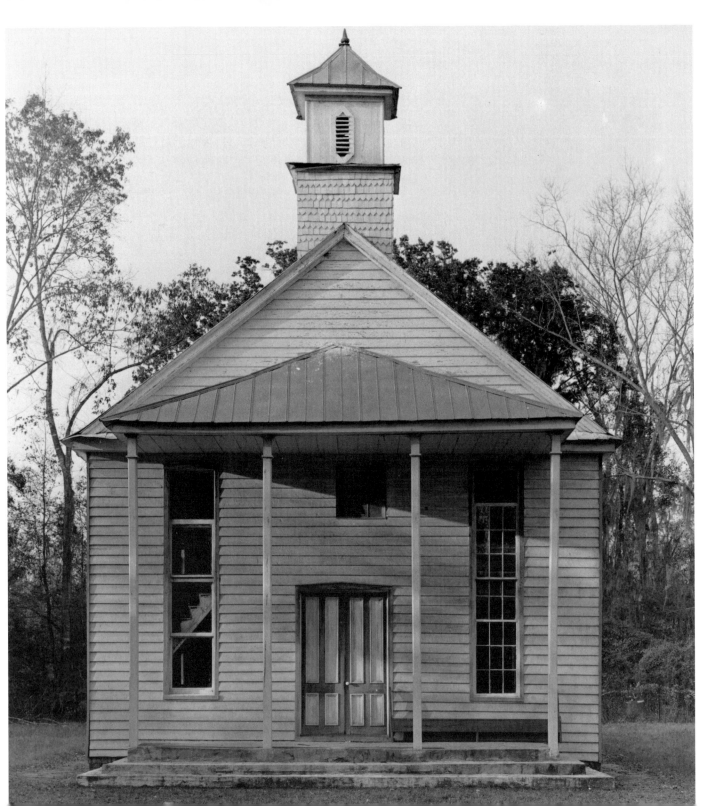

December 1948.
Gardens Corners. Huspath
Baptist Church.
MARTHA ROBERTS
University of Louisville Neg. 63517

December 1948. Port Royal.
Store owner F. W. Scheper.
MARTHA ROBERTS
University of Louisville Neg. 63514

135

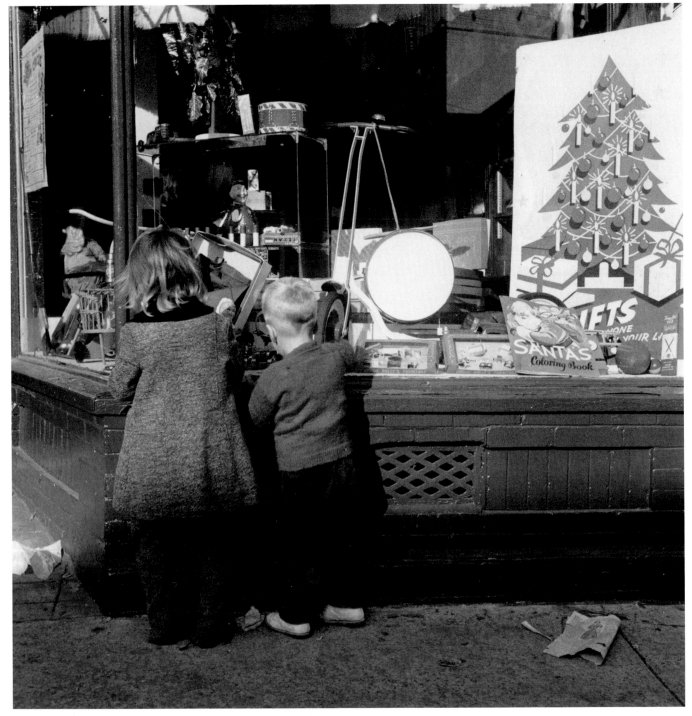

136

December 1948. Beaufort.
Window shoppers.
MARTHA ROBERTS
University of Louisville Neg. 63523

For Further Reading

On South Carolina During the 1930s and 1940s

William J. Cooper and Thomas E. Terrill, *The American South: A History*, Vol. 2 (New York: McGraw-Hill, 1990).

Walter B. Edgar, *History of Santee Cooper, 1934-1984* (Moncks Corner, SC: South Carolina Public Service Authority, 1984).

Walter B. Edgar, ed., *South Carolina: The WPA Guide to the Palmetto State* (Columbia: University of South Carolina Press, 1988).

Jack Irby Hayes, "South Carolina and the New Deal, 1932-1938" (Unpublished Ph.D. dissertation, University of South Carolina, 1972).

William David Hiott, "New Deal Resettlement in South Carolina" (M.A. thesis, University of South Carolina, 1986).

Lewis P. Jones, *South Carolina: A Synoptic History for Laymen* (Columbia: Sandlapper Press, 1971).

Ernest McPherson Lander, Jr., *A History of South Carolina, 1865-1960*, 2nd ed. (Columbia: University of South Carolina Press, 1970).

Ernest McPherson Lander, Jr., *South Carolina: An Illustrated History of the Palmetto State* (Northridge, CA: Windsor Publications, 1988).

Paul Stroman Lofton, "A Social and Economic History of Columbia, South Carolina, During the Great Depression, 1929-1940" (Unpublished Ph.D. dissertation, University of Texas at Austin, 1977).

John G. Sproat and Larry Schweikart, *Making Change: South Carolina Banking in the Twentieth Century* (Columbia: South Carolina Bankers Association, 1990).

On Documentary Photography

Pete Daniel, Merry A. Foresta, Maren Stange, and Sally Stein, *Official Images: New Deal Photography* (Washington, D.C.: Smithsonian Institution Press, 1987).

Maren Stange, *Symbols of Ideal Life: Social Documentary Photography in America, 1890-1950* (New York: Cambridge University Press, 1989).

Arthur Rothstein, *Documentary Photography* (Boston: Focal Press, 1986).

Alan Trachtenberg, *Reading American Photographs: Images as History, Mathew Brady to Walker Evans* (New York: Hill and Wang, 1989).

On the Farm Security Administration and the Office of War Information and Their Photographs

Sidney Baldwin, *Poverty and Politics: The Rise and Decline of the Farm Security Administration* (Chapel Hill: University of North Carolina Press, 1965).

James Curtis, *Mind's Eye, Mind's Truth: FSA Photography Reconsidered* (Philadelphia: Temple University Press, 1989).

Carl Fleischhauer and Beverly Brannan, *Documenting America, 1935-1943* (Berkeley: University of California Press, 1988).

Roy Emerson Stryker and Nancy Wood, *In This Proud Land: America 1935-1943 as Seen in the FSA Photographs* (Greenwich, CT: New York Graphic Society, 1973).

On the Standard Oil of New Jersey Photographs

Ulrich Keller, *The Highway as Habitat: A Roy Stryker Documentation, 1943-1955* (Santa Barbara, CA: University Art Museum, 1986).

Steven W. Plattner, *Roy Stryker: U.S.A., 1943-1950. The Standard Oil (New Jersey) Photography Project* (Austin: University of Texas Press, 1983).

On Individual Photographers

F. Jack Hurley, *Portrait of a Decade: Roy Stryker and the Development of Documentary Photography in the Thirties* (Baton Rouge: Louisiana State University Press, 1972).

F. Jack Hurley, *Marion Post Wolcott: A Photographic Journey* (Albuquerque: University of New Mexico Press, 1989).

Other Books of FSA/OWI Photographs for Southern States

Beverly Brannan and David Horvath, *A Kentucky Album: Farm Security Administration Photographs, 1935-1943* (Lexington: University Press of Kentucky, 1986).

Patti Carr Black, *Documentary Portrait of Mississippi: The Thirties* (Jackson: University Press of Mississippi, 1982).

Johnson Brooks, *Mountaineers to Main Streets: The Old Dominion as Seen through the Farm Security Administration Photographs* (Norfolk: The Chrysler Museum, 1985).

I. Wilmer Counts, Jr., *A Photographic Legacy* [Arkansas] (Bloomington: Indiana University Press, 1979).

About the Editor:

Constance B. Schulz has lived in South Carolina since 1985. She received her undergraduate training at the College of Wooster in Ohio and her Ph.D. in history from the University of Cincinnati. She is currently director of the Applied History Program at the University of South Carolina.

Schulz first became interested in photographic resources for the study of history while teaching at the University of Maryland where she compiled the *History of Maryland Slide Collection* as a resource for teachers of state history. In 1989 she created for South Carolina a similar resource, the *History of South Carolina Slide Collection,* that draws on pictorial resources from around the state to illustrate its history. She also edited the second edition of the *American History Slide Collection.* She recently served as guest curator for an exhibit of historical photographs, *Visitors' Views: A Century of South Carolina Documentary Photography,* at the South Carolina State Museum, the Greenville County Art Museum, and the Gibbes Art Museum. Her other publications focus on the history of American childhood and the early national period.

Professor Schulz is an amateur photographer and a violinist with the South Carolina Philharmonic Orchestra.